Wilder Wales, Compact edition published by Graffeg Limited in 2018.

First published by Graffeg Limited 2015. ISBN 9781909823075 with the financial support of the Welsh Books Council.

Author Julian Rollins, photography Drew Buckley, design and production Graffeg Limited. This publication and content is protected by copyright © 2018.

A CIP Catalogue record for this book is available from the British Library.

ISBN 9781912213665

1 2 3 4 5 6 7 8 9

Wilder Wales

Julian Rollins and Drew Buckley

GRAFFEG

Contents

Chris Packham

'I've reeled with choughs, spun with dolphins and soared with ospreys over the wonderful landscapes of Wales. What a richness!'

My eyes were watering as I peered over the Pembrokeshire cliff into a bitter March breeze to see my first peregrine's eyrie aged sixteen. At twenty-three I fell asleep in the sun on Skomer after staying up all night revelling in a shearwater spectacular and woke up surrounded by puffins wobbling like puppets into their burrows. The following year I nearly had a young sparrowhawk land on me as I lay on the Great Orme photographing a dark red helleborine and since then I've reeled with choughs, spun with dolphins and soared with ospreys over the wonderful landscapes of Wales. What a richness!

From the thick froth of lichens on Tregaron Bog, to the mossy boughs of Ynys Hir, to the deep wash of purple heather above the Rhondda Valley, the palette of colour, the crush of perfume and the sound of Wales rolls bright and bold in my memories of great wildlife moments.

From north to south, from high to low, from shore to scarp, this country embraces a remarkable diversity of habitats and consequently a huge range of species, including some great rarities. And they are accessible too, a superb collection of nature reserves, national parks and landscapes criss-crossed with a fine filigree of footpaths and especially

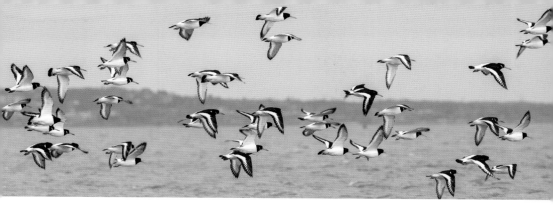

coastal paths, which allow all to enjoy the wilder side of Wales. And between them there is all the other infrastructure that the twenty-first century rambler or naturalist wants to enjoy, the boat trips, the tours, the hotels, the B&Bs, the pubs, and most critical of all... the hospitable people who meet you at their doors.

This book is a super calendar catalogue of the best places to visit, teasing us with a lovely portfolio of photographs but essentially equipping us with the practical information to make those visits a well organised reality. Because as much as these pictures can make us wonder, as much as wildlife on television may seem exotic, there is absolutely no substitute for the real thing. It's the tears in the eye, the sunburn on the brow and the heartbeat missed in anticipation of a real encounter that will generate an anecdote to tell, a memory to cherish. And when, at first, it rains and it's cold and you miss the moment of your dreams, then take all that and tuck it into your promise of success next time, because with wildlife it's the gaps in between that make those fleeting, unpredictable and awesome glimpses all the more special.

Once, I crawled up to the sheer edge of a blowhole near Marloes to peep down on some kittiwakes. In the rush of salty air which rose up that tube from the thunderous spume below, a fulmar floated on set stiff wings and came so close to me that I had to restrain an urge to reach out and touch it. I still feel that moment now, years later.

Chris Packham New Forest, 2014

Drew Buckley

Drew Buckley is one of the most accomplished landscape, wildlife and commercial photographers in the UK. Based in Pembrokeshire, Drew has been photographing professionally since 2010.

His images and articles have featured in hundreds of national magazines, including *BBC Countryfile*, *BBC Wildlife*, *Outdoor Photography*, *Digital SLR*, *Photo Plus*, *The Great Outdoors* and *Country Walking*; and national newspapers such as *The Times* and *The Guardian*.

Drew is the photographer and author behind another Graffeg book, *Puffins*, and also a range of south Wales calendars and cards. His clients include Pembrokeshire Coast National Park and many south Wales businesses & organisations. He also runs photography workshops and tutorials around the UK.

In 2017 Drew received his fourth Highly Commended at the British Wildlife Photography Awards and since 2012 has won awards at the GDT European Wildlife Photographer of the Year, International Garden Photographer of the Year, National Photography Awards, Outdoor Photographer of the Year and Bird Photographer of the Year.

To see more of Drew's work, visit www.drewbuckleyphotography.com

Julian Rollins

While other boys' heroes got muddy on sports fields, mine were the two Davids, Attenborough and Bellamy. I was fascinated by Attenborough's world travels, but it was the enthusiasm David Bellamy, the TV botanist, had for the close-to-home and every day that fired my imagination.

I spent days out exploring local woods and heaths. Thankfully, my seventies childhood was a free range one.

A news journalist by training, I now write about wildlife, the countryside and environment; my work has been published in a wide range of publications, including the *Daily Telegraph*, *BBC Countryfile* and *BBC Wildlife*. I'm lucky, I live in north Pembrokeshire, so I'm never short of inspiration.
www.julianrollins.co.uk

Introduction

I fell in love with Skokholm Island long before I set foot on it. A friend who had heard that I was booked in for a short visit sent me a gift that would, she said, prepare me for my stay.

What turned up was *Letters from Skokholm* by R.M. Lockley and yes, it was the perfect preparation for what turned out to be an all-too-short stay. Lockley lived on the island in the 1930s and 40s and the letters served a special purpose, they were each written to be sent to Ronald Lockley's brother-in-law, John Buxton, when the latter was a prisoner of war in a German camp during the Second World War.

Buxton was himself a naturalist. Each letter describes some aspect of the nature of that tiny island and must, I think, have offered some sort of escape from the tedium of POW life.

I fell in love with Skokholm Island long before I set foot on it.

For me they were an escape too. Lockley's way of writing vividly captures the spirit of the place. For example, when he writes of a family of choughs moving above "the bare cliffs like a group of great dark butterflies" I can see them in my mind's eye.

But from the moment our boat was buzzed by a pod of dolphins as we docked, Skokholm turned out to be even more incredible than the imagined one Lockley's letters had given me. On that modest slab of rock off the Pembrokeshire coast there seems to be more natural wonder per square inch than anywhere I've been to before.

There's something about TV wildlife documentaries that pre-conditions us to believe that the British Isles are rather tame, but Skokholm in August is dramatic. Surrounded by shearwaters in the dead of night, the idea for this book began to take shape.

Some time after my island visit I found myself in conversation with a father who was planning a trip away with his son. The boy, a wildlife-mad 10-year-old, had decided he wanted to see puffins and the father wanted to make a weekend of it.

Their plan was to go away together in the school summer holidays and have a day trip to Skomer Island. It put me in a bit of a fix; I had to tell them that while Skomer is worth a visit at any time of year, in August its puffins are long gone.

So, a celebration of the wild places of Wales, but also one that reflects the way they change from season to season. Altogether it has added up to an exciting journey to the four corners of Wales for

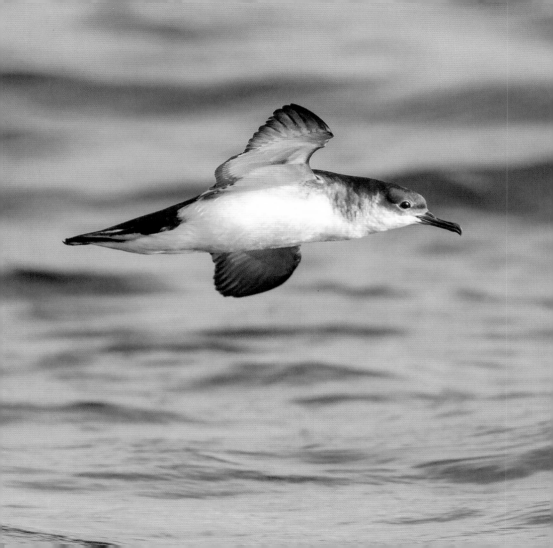

myself and for talented photographer Drew Buckley.

Along the way I learned quite a bit. For example, if you're planning to sleep in a camper van in a lay-by on the A525 before going to a black grouse lek, take earplugs; the bikers race until around 3am, the black grouse are up for 5am.

I feel that I also need to add just a word or two about what this book is not – and that's a definitive Top 12. When we planned our tour of Wales we decided to go for a year's worth of wildlife experiences, each of which would make the average person say "wow".

That's fine, but I soon hit on a problem – what to leave out. There is so much to see in Wales that every month had worthy candidates that, sadly, couldn't make the final cut. It means that the final dozen are mine, and mine alone. For example, Skomer is a marvellous place and one that everyone should go to at least once, but it didn't get a chapter of its own.

That's because I wanted to include two less well-known Pembrokeshire islands (Skokholm and Ramsey) and Pembrokeshire could not be allowed to take over our year. Apologies then, Skomer, I hope you understand.

There were other considerations too. Originally I wanted to include the Snowdon lily, a plant that encapsulates the wildness of Snowdonia.

Now very rare, it grows on inaccessible rock faces. Then it occurred to me that the lily's inaccessibility could be a problem; it takes climbing skills to find a Snowdon lily. Could I sleep at night if readers were shinning up rock faces at my suggestion?

So, I hope that Drew's stunning images, and my descriptions of our visits, will inspire you to follow in our footsteps. If you do, please take care; wild places deserve respect, so check weather forecasts, think about tide times and let someone know where you're planning to go and when you are likely to be back.

Most of all though, I hope you enjoy the ride as much as we did.

Julian Rollins, July 2014

Left: A Manx shearwater cruises across the Irish Sea waves. These amazing seabirds migrate to breed on Skomer and Skokholm every year, all the way from South America.

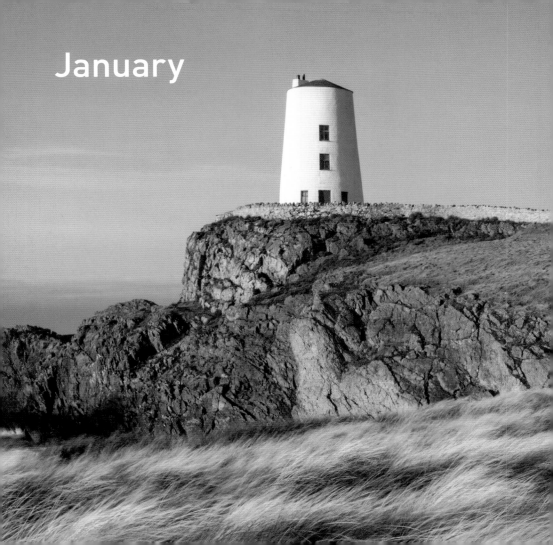

January

1. Home to roost
Newborough Forest and Warren, Newborough, Anglesey

Newborough Warren and Forest are on the southern 'corner' of Anglesey, just off the A4080 coast road.

At the end of a bright day that's been as good as January has to offer, the late afternoon sun has gone from the sky. And the temperature is dropping sharply.

Alongside the track into Newborough Forest moss-covered outcrops of rock stand out among ranks of plantation conifers, witness to the coastal dune landscape lost when the foresters came to Anglesey. In time there's a break in the trees and I get a first view across the marshes of the Cefni Estuary to the west and the last of the day.

Back in the 1950s and 60s the great wildlife artist Charles Tunnicliffe lived in a house on the far shore. The Cefni was an inspiration and the estuary's birds featured in much of his work.

Right on cue, a pair of ravens are flying on a direct course that will get them to a shared destination – theirs and ours. Somewhere close to the heart of the forest is Britain's biggest raven roost, a gathering that attracts hundreds of the birds each winter night.

Ravens have a certain something. The biggest member of the crow clan is confident and charismatic.

Some of that is about the bird itself. Ravens are smart and playful, but it's also about how we perceive them, and that's thanks to many centuries of folklore.

On the track by the estuary it's only when we turn away from the view that it becomes apparent that we have been watched. A single raven is sitting overhead in the branches of one of the pines acting as sentry.
On being noticed, it lifts its head in a way that opens out the fan of feathers at its

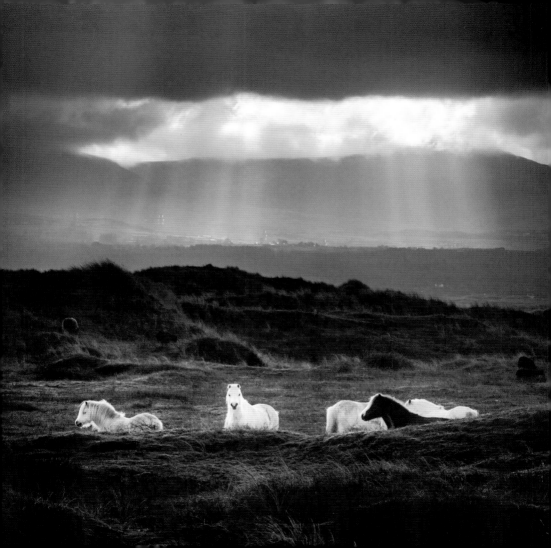

Above: The magnificent coastal Warren habitat and pine forest at Newborough, home to a wealth of wildlife.
Right: Sunrise on Llanddwyn Island with the morning sun hitting the lighthouse of Tŵr Mawr and the peaks of the Llŷn Peninsula in the distance.

throat and caws. In the quiet of twilight it's a sound that's deep and raw and seems to scold us as trespassers.

The ravens' stronghold, Newborough Warren and Forest, is a fascinating place. Its sand dunes are among the richest in Wales and its beach, with its backdrop of mountains, is almost certainly a shoe-in to any Welsh beach top 10.

The 'new' borough is actually seven centuries old. In the late 1200s, England's King Edward I had a new castle built at what became Beaumaris and local people were evicted from the site.

They were moved across the island to Rhosyr, which was renamed Newborough. The land between the village and the coast was once fertile farmland, but it was later lost when sand dunes moved inland.

The harvesting of marram grass to make rope and nets was blamed. Dunes

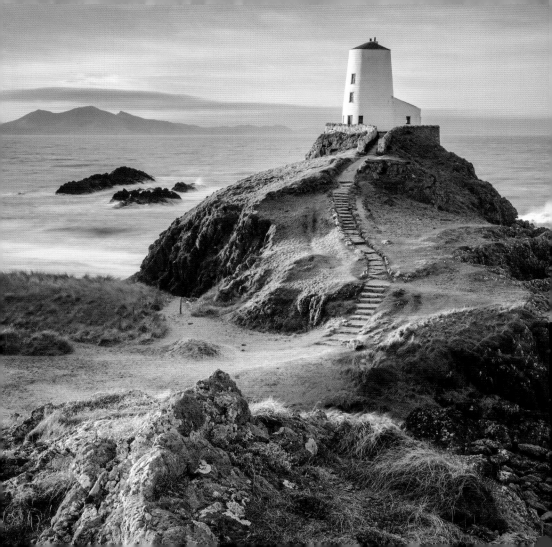

Left: Pillow lava is basalt rock that erupted on the ocean floor. The lava oozed out of any gaps as small blobs which cooled rapidly in the cold sea water. The fissures contain blood red jasper, greyish quartz, lime-green epidote and milky calcite.
Right: Twˆr Bach beacon was the original lighthouse on Llanddwyn Island, to help provide guidance to ships heading for the Menai Strait.
Below right: In Wales, Anglesey is one of the last strongholds for the red squirrel. With an active management programme in recent years, the island's squirrels are now thriving.

became unstable when the grass was cut.

Today, grey-green marram is the dominant plant across a large area of the Warren, where it grows alongside plants like dune pansies, sea spurge and sand cat's-tail. Some dunes were lost when Newborough Forest was planted, but even so the dune system is still one of Wales' finest.

Waiting for dusk and ravens there is plenty more to see at Newborough. At low tide, head out to Ynys Llanddwyn, which in medieval times was on the pilgrim trail. Travellers walked to the island to be blessed at St Dwnywen's Well; the patron saint of lovers, Dwynwen's memory is still celebrated each year on January 25.

Exploring the island, with its ruined church and landmark lighthouse, is fascinating. On its beaches look for strange pillow-shaped rocks that are flecked white and deep red, colours that shine when wetted by the surf.

More than 500 million years old, they are among the oldest rocks in Wales and were formed when lava bubbled up through cracks under the sea. The lava's heat 'cooked' sand and mud that it came into contact with, transforming it into deep-red jasper and green epidote.

January is also an excellent time to go looking for Newborough Forest's red squirrels – the forest is one of the best places in Wales to see them. In the second half of the winter females come into season and there are high-speed, high-level chases when males chase females through the treetops.

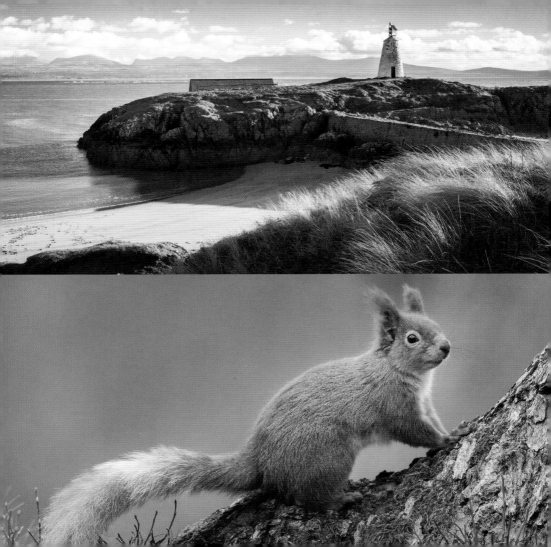

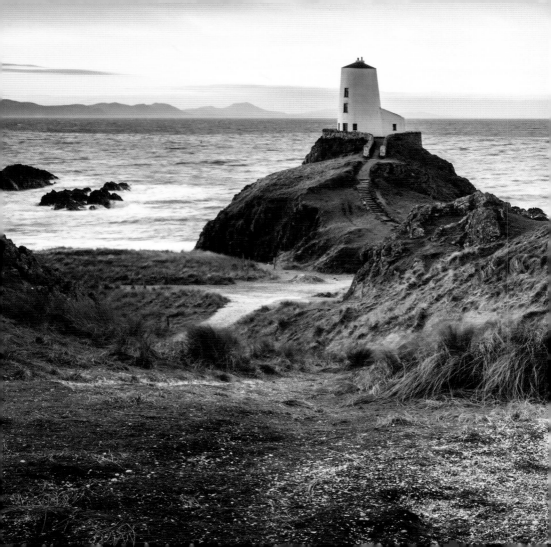

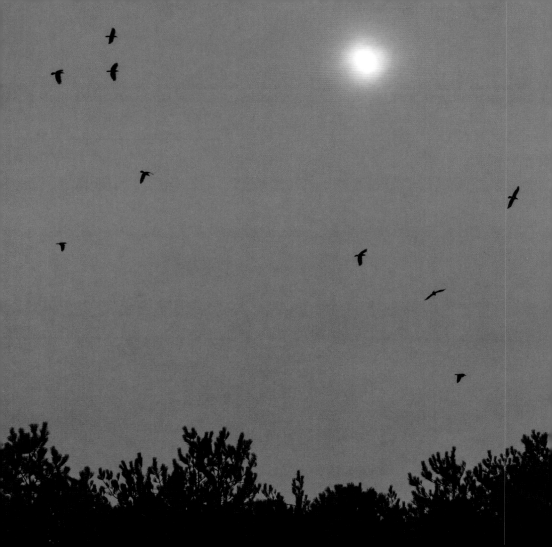

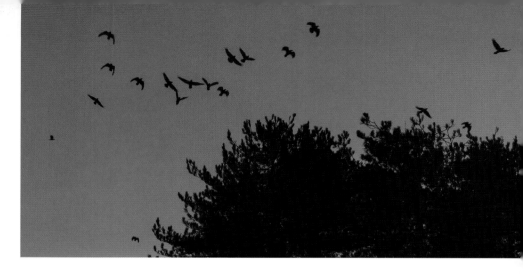

Above and left: Flocks of ravens congregate above the forest at Newborough.

Since the introduction of the grey squirrel , Britain's native squirrel has become very rare. The first grey was recorded on Anglesey in the 1960s and reds came under pressure as greys colonised the island.

By the mid-1990s the reds were all but extinct. However, a last-ditch effort to halt the decline has seen Anglesey become a red squirrel stronghold. A sustained cull of grey squirrels has cleared the island and captive-bred reds have been released.

The first red squirrels were released at Newborough in 2004 and by the end of that year 23 youngsters were born. Since then the squirrel community has gone from strength to strength and the forest is being managed to make it more squirrel-friendly, with trees like oak, hazel and chestnut being planted among the pines.

There's plenty to see, but as the day begins to end the ravens become the main 'show'.

It's worth saying at this point that the crow family, the corvids, can be an ID challenge, because the four black corvids are quite similar.

In Wales, the jackdaw is common and

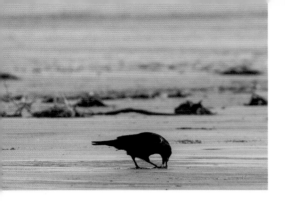

Left and right: Newborough beach can be a treasure trove after winter storms. While it looks long, bleak and uninviting, it holds a wealth of food for the wildlife there. Here, a raven feeds on a washed up mussel whilst oystercatchers catch some well earned sleep before the tide recedes to start feeding again.

widespread. The smallest of the four, jackdaws are easy to distinguish from the others – look for grey plumage on the neck and head and blue eyes.

Rooks are larger than jackdaws (45cm long against the jackdaw's 33cm) and have a long beak and a pale grey face. Then there's the carrion crow; it's about the same size as a rook, but does not have the grey face.

It's the carrion crow that is most often mistaken for a raven. See the two birds together and the difference is obvious, because ravens are big; an adult is about 60cm long.

Of course, you're unlikely to find the two birds standing side by side. The clues that tell you that you are in the presence of a raven are solid build, stout beak, a mane of feathers and an impressively deep and varied range of vocalisations.

The raven is a bird with presence. In the past the verb 'to raven' meant to obtain, or seize, with violence and Viking armies followed a raven banner. It's a bird that effectively fills the niche taken by vultures in other parts of the world.

But then there's also something comical about a raven. Charles Dickens had a pet raven and he included a raven character named Grip in his novel *Barnaby Rudge*.

His descriptions of Grip feel observational. For example, when Grip lands and goes to Barnaby it is "not in a hop, or a walk, or run, but on a pace like that of a very particular gentleman with exceedingly tight boots on, trying to walk fast over loose pebbles".

On the whole though, ravens have been associated with death. That deep, throaty call, its presence in remote wild places and the way it tended to appear after battles has earned the raven a reputation as a bird of ill-omen. Where the collective noun for a flock of goldfinches is 'a charm', a group of ravens is 'an unkindness'.

Above: Fire in the sky. An amazing sunrise over the Snowdonia mountain range viewed from Llanddwyn Island.

Light all but gone, in the cold heart of Newborough Forest I'm pondering ravens and the supernatural and very aware that I forgot to bring a torch along for the walk back to the car. As numbers grow, the birds take up position in the upper branches of the pines.

They are hidden from view, but can be heard – the constant calls of bird-to-bird communication. It's thought that around 800 ravens get together in the forest each night in what is essentially a social gathering.

The Newborough ravens are juveniles that have not found a mate or singles that have lost a mate. The roost is an opportunity to meet members of the opposite sex.

But it seems that it's also an opportunity to exchange useful information. The raven brain is one of the largest of any bird and the bird's repertoire of calls includes more than 30 distinct sounds.

One study of Newborough's ravens has thrown some light on how the roost is an information exchange. Sheep carcasses marked with coloured beads were left some distance from the roost and then researchers checked for regurgitated

beads below the roost trees.

One morning some coloured beads were found. Next morning, more beads, and then more on following days.

It seems good news is shared. When the light had all but gone we walked out of the forest, listening to the ravens – and wondering what they were saying.

Visit

Newborough Warren and Ynys Llanddwyn are managed by Natural Resources Wales (naturalresourceswales.gov.uk). The reserve is open all year round and free to visit. There is a large car park (grid ref. SH405 635) near the beach, at the end of a minor road that is signposted from Newborough. Alternatively, park at the smaller car park (grid ref. SH412 670) near Malltraeth Sands, which is close to the raven roost (grid ref. SH402 652) at the heart of the forest.

Also

Llangorse Lake (breconbeacons.org), near Brecon, is the largest natural lake in south Wales and attracts large numbers of ducks and geese in mid-winter, as well as other wintering waterbirds like bittern and water rail. There is a bird hide on the south shore at Llangasty (SO 126 263).

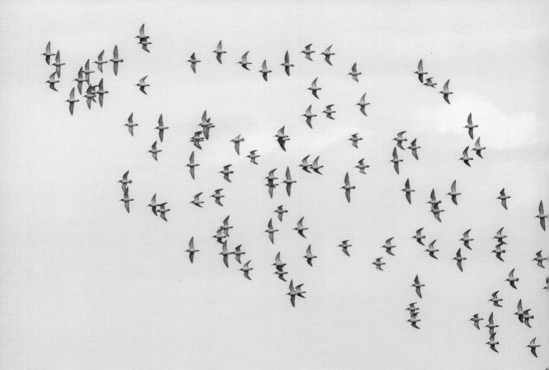

February

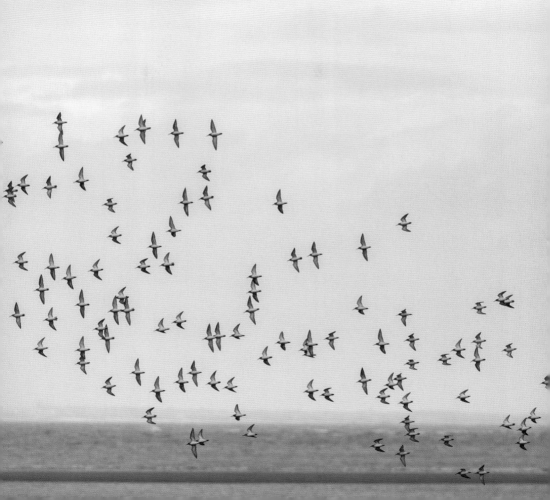

2. Time and tide
Point of Ayr, Dee Estuary, Flintshire

Point of Ayr is at the mouth of the River Dee. It is 3 miles (5km) east of Prestatyn on the A548.

Roughly two-and-a-half hours before high tide, the view from the sea wall at Talacre is of a seemingly unbroken expanse of mud. About half a mile (0.75km) to the east the windows of buildings along the sea front at West Kirby catch the afternoon sun, but it's hard to make out much detail in the intervening wilderness that is the estuary of one of Wales's great rivers, the Dee.

The River Dee, Afon Dyfrdwy, is 70 miles (110 km) from source to mouth and along some of its length it's a border. Somewhere between Talacre and West Kirby, Wales ends and England begins.

At low tide it looks as though you could walk all the way across. Which is, of course, a mistake; most of what can at times look like firm ground is actually silt, soupy mud that's the consistency of thin porridge.

It's heaven for wading birds, and in winter they come in their many thousands to forage in the mud zone. A few live on the Dee all year round, others move from elsewhere in Britain to winter on the river, while there are also birds that use the Dee as a stepping stone on a long-distance journey that can see them travelling between continents.

It makes the Dee a location of international importance for birds. In fact, the estuary is one of Britain's most important wetland habitats and is one of around 2,000 around the world listed by the international Convention on Wetlands (Ramsar Convention).

Right: Talacre beach lighthouse takes a battering during the storms of winter.

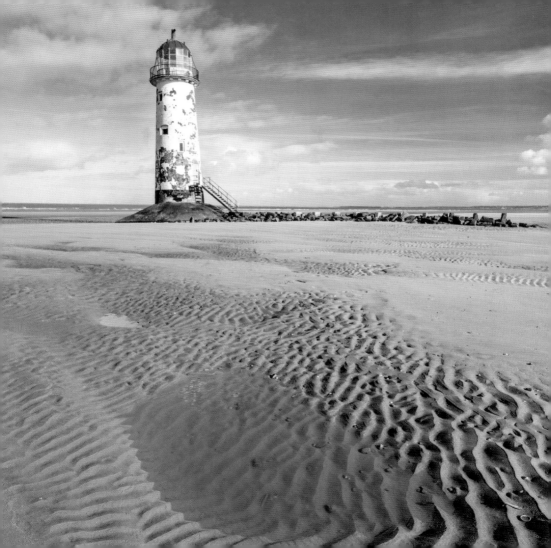

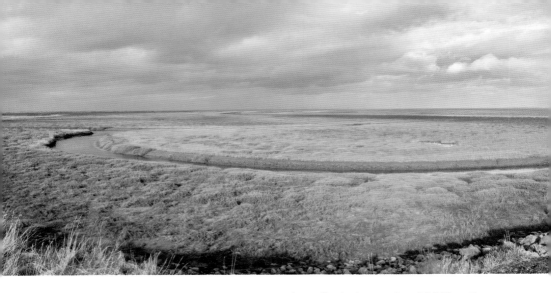

Above: The view from the hide across the vast salt marshes towards the Dee Estuary.

The birds that make up the flocks change from month to month. Between autumn and spring, as many as 20 different species of wader alone can be seen on the Dee, often in flocks that number thousands of individuals.

And it's the numbers that make birdwatching on the Dee one of Wales's great wildlife spectacles. For example, the knot is a small, grey wading bird that's easy to overlook when it is feeding on the shore, but a flock of more than 20,000 on the move is spell-binding.

Seeing the 'show' in its full glory is a question of location – and timing. The best spot on the Welsh side of the river is almost certainly the Point of Ayr nature reserve, which is at the river's mouth.

The Point of Ayr is a short sand and shingle spit that is shaped, appropriately, like a bird's head and extends out into the estuary. To the west of the spit there's an old lighthouse and miles of beach, while to the east are mudflats and saltmarsh.

Being in the right place is important, but so is being there at just the right time.

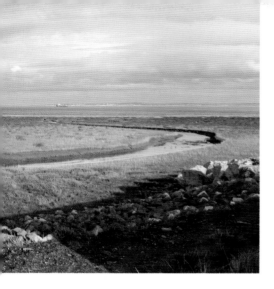

The lives of the waders and wildfowl that populate winter estuaries are dictated by the movement of the tides. Estuary mud is an incredibly productive habitat in which invertebrates – like worms and shellfish – thrive on nutrients delivered by the river's flow.

It means that there is lots for hungry birds to eat, but only for the few hours on each tide during which they can get at it. What makes the estuaries of the British Isles so attractive is that feeding grounds are bigger.

That's because the rivers of Britain and Ireland have relatively large tidal ranges

– the sea moves further between high and low tide. The tidal range of the Dee is not as great as that of the Severn (which has the second biggest tidal range in the world), but it comes close.

Birds that congregate on the Dee in winter fall into two categories, wildfowl and waders.

The power of this movement of water is brought vividly to life on those rare occasions when a tidal bore sweeps up the river. The River Severn's tidal bore is well-known, but other rivers around

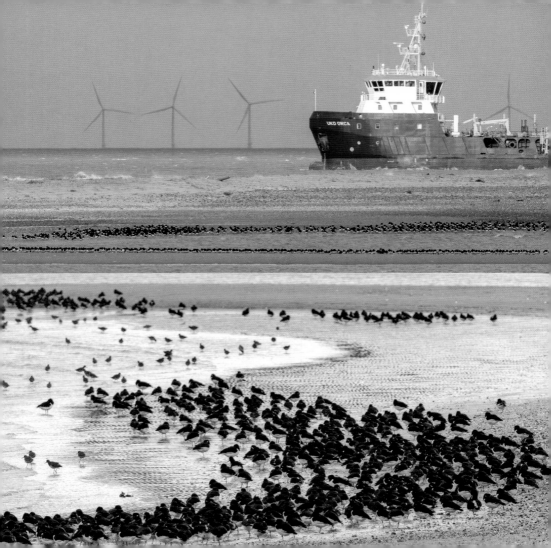

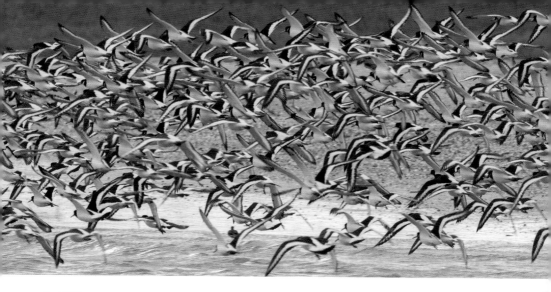

the UK have a similar phenomenon – including the Dee.

Tidal bores are a comparatively rare phenomenon. There are thought to be fewer than 100 in the world and many of them happen on Britain's rivers. Many British rivers have a bore, which says a lot about how tides influence our coast.

The first of the year's biggest high tides happen in February. Tides are higher in March, but by then the winter flocks are moving on and there are fewer birds to see.

Most of the birds that congregate on the Dee in winter fall into two categories, wildfowl and waders. Wildfowl are ducks and geese, birds that have webbed feet, while waders have long legs and long bills – they are perfectly adapted to life at the margin between water and land.

With a two-hour wait for the rising tide on the day of our visit to Talacre, the birds are busy foraging for food over acres of mudflat. Even with binoculars, most are too far away to be identified.

Left and above: Oystercatchers congregate along the line of the rising tide until there's no beach left, at which point they take flight en masse.

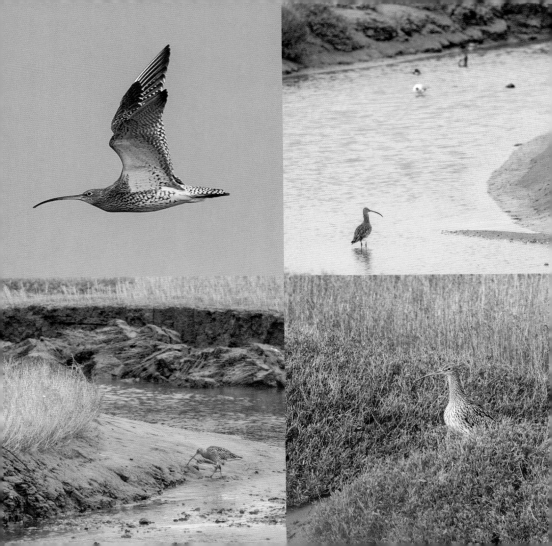

Looking into the far distance it's hard to say what is mudbank and what's open water. But there are small channels through the marsh close to the hide that have water in them and some birds are busy there.

The whistling calls of a little flock of teal can be heard above wind, as well as the persistent piping of redshank. Then there's a burst of noise and movement as a sparrowhawk stages an ambush, flushing half a dozen sandpipers from a channel close by.

The hawk quickly peels away from the pursuit as its targets make their getaway, flying low and fast towards England. Winter estuaries are great places to see birds of prey, which are attracted by all the potential prey; if you're very lucky you may see a peregrine falcon chase down a wader along the shoreline, or short-eared owl patrolling marshland.

The hawk's near-miss disturbs the birds on the marsh, but all soon return to foraging. As the tide rises the waders concentrate their attentions on the water's edge; it's easier to probe damp mud. A dainty redshank, busy along the waterline close by, looks tiny alongside a curlew, the largest of the Dee's waders.

Some birds' migration journeys cover long distances, others are relatively short. A redshank feeding on the Dee in winter could have spent its summer in England or Scotland, or around 1,000 miles away in Iceland.

A curlew may have spent its breeding season in the uplands of Wales. In February it will be preparing to make the return journey, or it could face a long-haul trip to Scandanavia or Russia.

A curlew may have spent its breeding season in the uplands of Wales.

For the beginner birdwatcher, wader identification can be a problem. Lots of the species look very similar, but that's not the case with the curlew. Its long, down-curving bill makes it easy to ID, as does its evocative call.

Beak length is key to how it is that so many different sorts of birds can feed alongside one another on the mud. Curlews can probe far deeper than redshank can. It means that curlew can reach lugworms and ragworms, while redshank concentrate on smaller invertebrates closer to the surface.

With a little over half an hour to go to high tide, more of the mudflats are lost

Left: The muddy tidal inlets on the salt marsh are a great place to look for many wading birds, especially curlew.

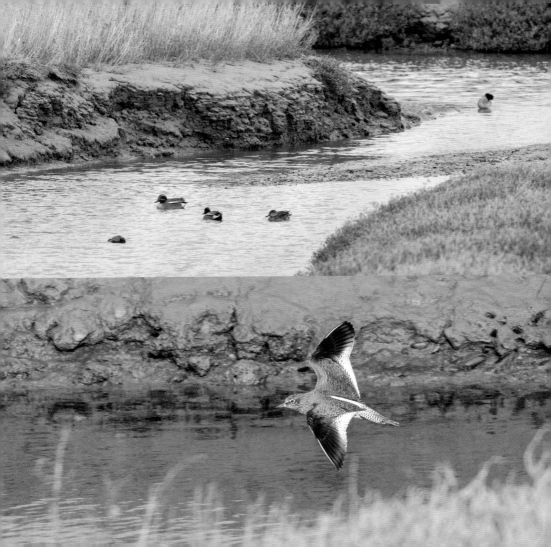

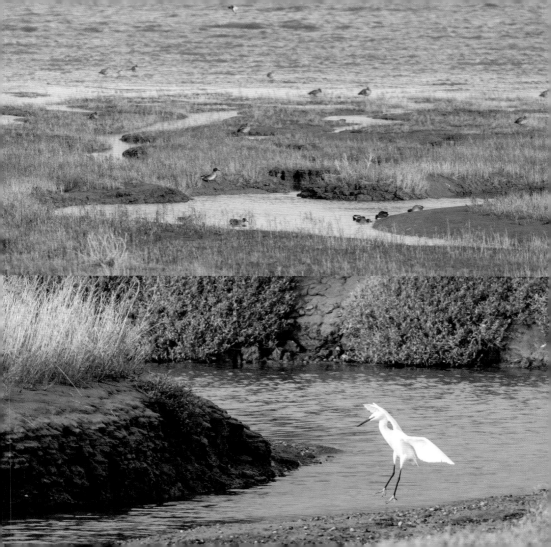

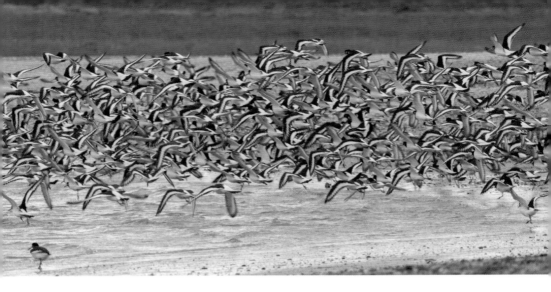

to the sea and birds begin to crowd together. As they move around the estuary distant wader flocks seem like smoke, but closer in it's possible to make out individuals and see how closely each one follows its neighbours.

Somewhere over West Hoyle Bank, where grey seals haul out to rest, a wader flock flies low and fast. For a moment it seems that the flock will land, but the birds do an about turn and sweep up and away.

Being one small part of a huge flock has its advantages. A member of a flock is less likely to become a meal for a predator – one pair of eyes on the lookout is much less effective than a hundred pairs, or a thousand.

It's also harder for a predator like a peregrine to close in on a single bird when it's part of a fast-moving group. And living in company helps too because birds can see where food is most plentiful by keeping an eye on how others are faring.

As high tide approaches, birds return to their roosting sites around the estuary. The daily routine of feeding and resting is dictated by the tides rather than by the rising and setting of the sun; if the tide is out at night, that's when birds will feed.

Right: A stroll along the beach can yield great finds like this mussel washed up along the tide line.

We watch as little flocks of oystercatchers are heading in to their roost out in the shelter of the Point of Ayr. The oystercatcher is one of the Dee's best-looking birds.

Their striking black-and-white plumage has earned oystercatchers the nickname 'sea-pie', because they have something of the magpie about them. To me though, a perfectly synchronised flock of oystercatchers look more like a Napoleonic army's well turned-out guards regiment.

Some oystercatchers breed on the Dee, but in winter they are joined by birds from Norway and Iceland.

In February there can be around 20,000 oystercatchers on the estuary, feeding when they can on cockles and mussels. At the Point of Ayr roost up to 4,000 birds gather, squabbling over the best spots when they first fly in.

We watch as they settle, standing head into the wind to keep plumage in place. As they come to rest, birds tuck their beak and a leg under their feathers to roost. It's a half-waking, alert sort of sleep, but it fills the time until the tide drops and the twice-a-day routine starts over.

Visit

The Point of Ayr reserve (grid ref. SJ124848) is managed by the RSPB (www.rspb.org.uk/reserves). It is open all year round and free to visit.

Also

Wales has plenty of estuaries that are worth visiting in February and each offers a different experience. The Dyfi (grid ref. SN442957) is a good place to see ducks, including shelduck and wigeon, while the Llwchwr (Loughor) attracts large numbers of wildfowl and waders, including both black-tailed and bar-tailed godwit. The National Wetland Centre (www.wwt.org.uk) at Llwynhendy is well worth a visit to see the birds that gather at its lagoons, including the little egret.

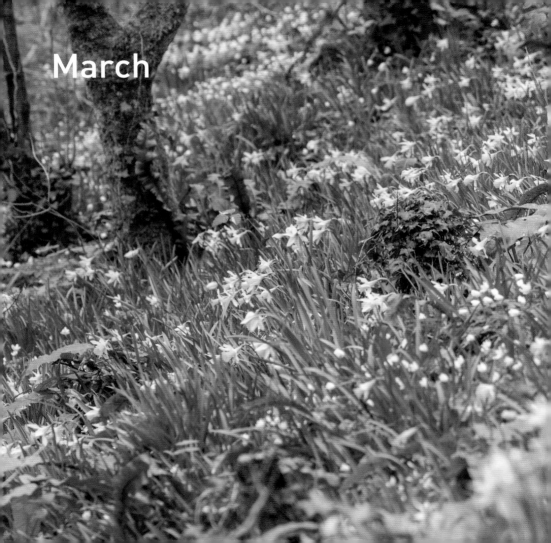

March

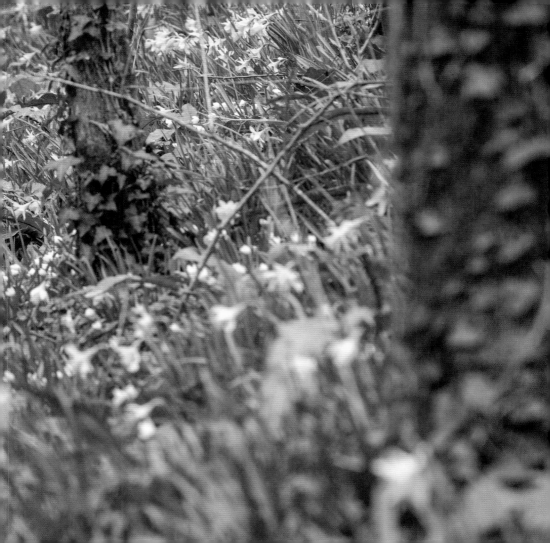

3. Colour scene
Coed y Bwl, Vale of Glamorgan

Coed y Bwl is 5km south of Bridgend, close to the village of St Bride's Major.

March can be an unfriendly month, which makes the splash of colour that daffodils bring so welcome. The genuine herald of spring, the wild daffodil, is much harder to find these days, but you can still see them in some Welsh woods and meadows.

Wherever you come across them they are a treat to see, but in a few locations you can find them in the sort of numbers that would once have been a familiar sight. And nowhere can quite match Coed y Bwl.

In the steep-sided limestone valley of the Alun, trees cover the slopes, growing tall and straight. On an overcast morning there's a sharp-edged wind, which moves the leafless branches overhead so that

they rattle together and convinces me I should have brought gloves.

Later in the spring Coed y Bwl will be busy with singing birds; summer visitors like chiffchaffs, blackcaps and willow warblers will bring the valley to life with their song. But on a mid-March day it's relatively quiet.

Fieldfares cluck to one another from upper branches of ash trees. Winter visitors, they will soon be heading north to spend their summer closer to the Arctic.

Some way off a buzzard is calling, but otherwise there's little to hear. In fact, it's so quiet it's possible to make out the low drone of a big bumblebee, which is working its way from flower to flower.

At the tail end of winter bumblebee queens emerge from hibernation. They sleep through the colder months, waking when temperatures begin to rise. With their reserves of energy depleted, their first priority is to have a nectar feed and

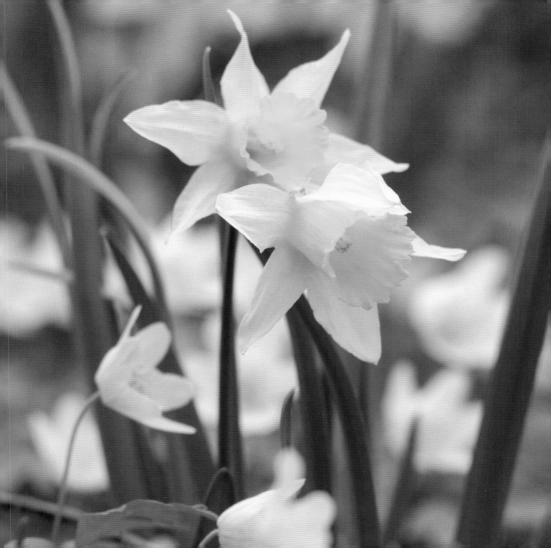

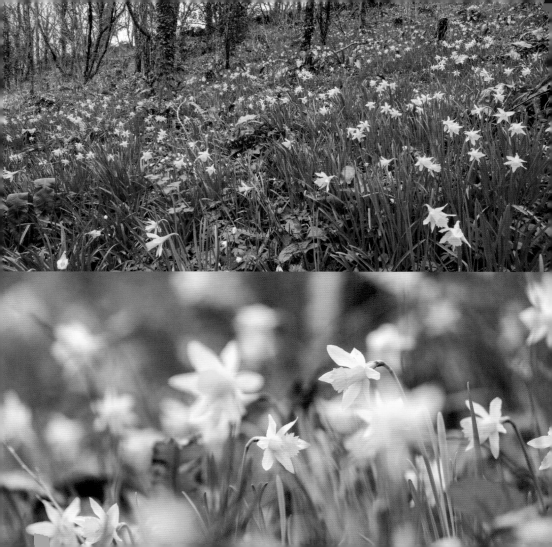

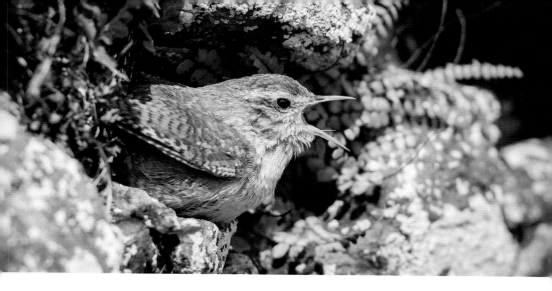

so they go looking for flowers.

And they find plenty of them in woods like Coed y Bwl. Everywhere there's new growth pushing through last autumn's dead leaves, including thousands and thousands of daffodils.

As far as the eye can see the woodland floor is covered by them, heads stirring in the morning's breeze. Put side by side with the more familiar, garden-grown daffodil, a wild daffodil (Narcissus

Left and above: Stunning Welsh daffodils and beautiful bird song, a real boost of life after the relatively dull winter months.

pseudonarcissus) looks a little puny. It's smaller (growing just 30-40cm tall) and its flower heads are not held straight like the typical garden daff, but droop a little.

Their colour is more muted too. In place of the bold yellow of a cultivated plant, the wild daffodil's flower has a yellow trumpet, or corona, but has petals that are paler.

For all of that, a colony of many thousands of wild daffodils is a remarkable sight. The flowers are at their best just as the wood's trees are shaking off their winter dormancy, with leaf buds swelling and beginning to burst open.

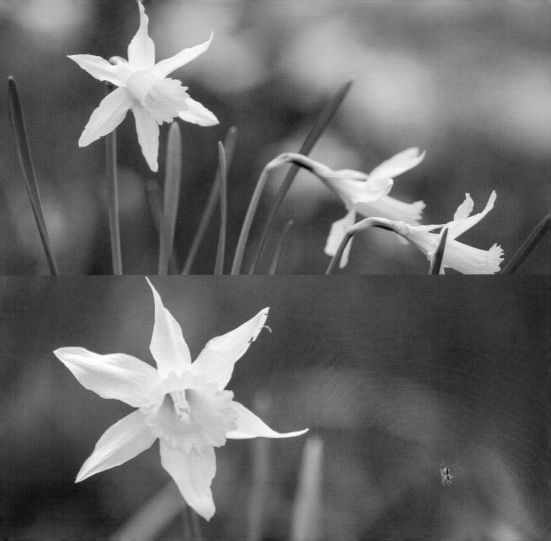

In amongst the daffodils a few other plants are in flower too. Wood anemones carpet the ground and, along path edges, there are the star-shaped flowers of lesser celandine.

Sometimes called the Lent lily, the wild daffodil is the flower that inspired what is perhaps Britain's best-known poem, William Wordsworth's 'I Wandered Lonely as a Cloud'. It's often known simply as 'Daffodils' and describes a walk that Wordsworth took with his sister Dorothy by Ullswater, in England's Lake District, in the spring of 1802.

It opens:
I wandered lonely as a cloud
That floats on high o'er vales and hills,
When all at once I saw a crowd,
A host, of golden daffodils;
Beside the lake, beneath the trees,
Fluttering and dancing in the breeze.

Dorothy wrote about their walk too. In her journal she recorded: "I never saw daffodils so beautiful, they grew among the mossy stones about & about them, some rested their heads upon these stones as on a pillow for weariness &

Left: The wild daffodil is a lot smaller and more muted in colour than overly-large, and very yellow, commercial flowers.

the rest tossed and reeled and danced & seemed as if they verily laughed with the wind that blew."

For all that Wordsworth celebrated daffodils, Wales 'owns' them. March in Wales is about daffodils, leeks – and rugby. During the Six Nations there are plenty of daffodils and leeks to be seen at the Millennium Stadium; they are there as hats, as inflatables, pinned to lapels.

...for more than a century there has been a debate over leeks, daffodils and St David's Day.

Both have become emblems of Welshness, but that is a relatively recent state of affairs. In fact, for more than a century there has been a debate over leeks, daffodils and St David's Day.

At times the disagreement has been quite pointed. The most influential supporter of the daffodil cause was the Prime Minister David Lloyd George.

One 'fact' sometimes cited in support of the daffodil is that Lloyd George wore one at the investiture of the Prince of Wales at Caernarfon in 1911. The problem with that claim is that the investiture took place in July, long after daffodil flowers had shrivelled.

Stories supporting the case for the leek are a lot older, but possibly no

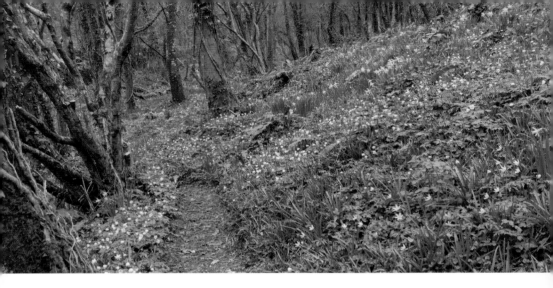

Above: It's a relatively short and undemanding walk around the wood and if you time it right, there's a vast array of wild flowers on show.

more reliable. One says St David himself suggested soldiers off to fight Saxons should wear leeks so that they would know friend from foe in the heat of battle.

Another remembers the Battle of Crécy in 1346. The Welsh archers who played a significant role in the victory are said to have done their lethal work while standing in a field of leeks.

Writing in 1919, the Cardiff botanist Eleanor Vachell described how the "hardy annual" controversy aroused passion on both sides. Supporters of the daffodil called the leek "an obnoxious garden vegetable", she said, while opponents referred to the daffodil as a "sickly, maudlin, sentimental flower".

Blame for the confusion may belong with William Shakespeare. Did he mistake the cennin Pedr (Peter's leek, or daffodil) for the cennin (leek)?

Eleanor Vachell came to the conclusion that while daffodil had only been spoken

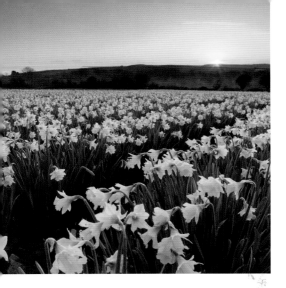

It is something of an enigma. For a start, botanists have not been able to agree whether or not the Tenby daffodil really deserves to be a species in its own right.

Some experts regard it as a separate species with the scientific name Narcissus obvallaris, but others believe it should be classed as no more than a sub-species of the wild daffodil. There's even a theory that it is a relocated Iberian, the Spanish daffodil (*Narcissus hispanicus*).

A final ruling on the Tenby daffodil will have to wait for DNA analysis. In the meantime, there's the other question – whether the Tenby daffodil is a species or not, how come west Wales has a daffodil of its own? A popular theory tells of bulbs arriving with Phoenician merchant adventurers, who are thought to have travelled to Wales long ago.

From home ports on the coast of what is now the Lebanon, the Phoenicians traded Egyptian and Syrian goods and by around 700 BC they were operating all over the Mediterranean. But they also travelled further, and there is a tradition in Cornwall that some Phoenician seafarers who first came to buy tin, later chose to stay as settlers.

So, one story has it that a Phoenician ship blown off course arrived in Pembrokeshire's Saundersfoot Bay, where they found local people using high-quality coal mined nearby. The merchants returned in later years and traded a cargo of daffodil bulbs for a cargo of coal.

It is a nice thought. More likely is that medieval monks from France or Spain brought the Tenby daffodil along with them, perhaps for its healing properties.

However it happened, the Tenby daffodil thrived in southern Pembrokeshire and by the early 19th century it had become a valuable commodity. Bulbs were dug up in large numbers to be sent for sale at Covent Garden in London.

Right: Coed y Bwl volunteers' good house-keeping earned the wood a Prince of Wales Award in 1975 as part of a nation-wide scheme to improve the countryside.

Demand for bulbs for the horticultural trade was so intense that the daffodil became a rarity in and around Tenby itself. Where it does grow now on verges and roundabouts, it is often as a result of recent planting of cultivated bulbs.

In the past the wild daffodil suffered in a similar way, with bulbs uprooted to be offered for use in gardens. However, it's thought that the impact of bulb-digging played a relatively small part in population decline since the 19th century.

Clearance of woodland has probably played a more influential part in the decline, along with changes to the way the land is farmed. Whatever the cause though, it means that woods where wild daffodils do still thrive – like Castle-upon-Alun – are now particularly special.

Visit

Coed y Bwl nature reserve (grid ref. SS 909750) is managed by the Wildlife Trust of South and West Wales (welshwildlife. org). It is open all year round and is free to visit.

Also

The first of the birds that migrate north to Britain arrive in late March. At the end of long sea crossings, birds drop down to rest and feed at the first land they reach, such as islands and headlands. Among the first to arrive are wheatears and ring ouzels, which breed in upland areas. Good locations for migrant-watching include the island of Flat Holm (grid ref. ST 221 649) in the Severn Estuary (flatholmisland.com) and Great Orme, Llandudno (grid ref. SH 757 838).

April

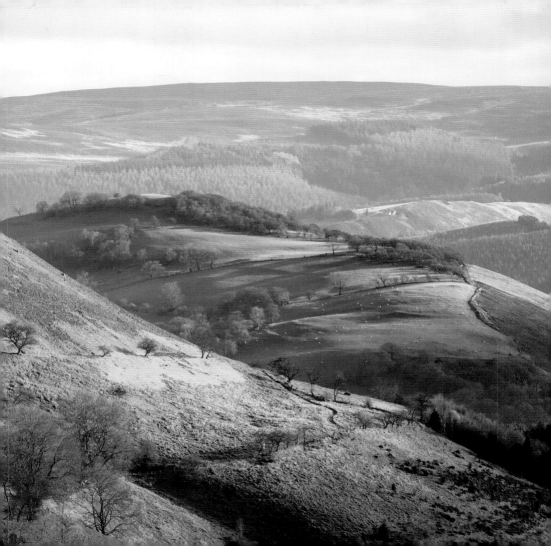

4. 'Ghosts' in the mist
Coed Llandegla, Denbighshire

The Coed Llandegla visitor centre is just off the A525. It is 6 miles (10km) west of Wrexham.

Seeing a black grouse lek is something people will travel for. It's a piece of wildlife theatre that is definitely worth getting up early to see, but the 'actors' rarity also adds appeal.

Maybe that should be grand opera – rather than theatre – because it is an event that has sex, conflict – and song.

Unfortunately, on our chosen morning in late April it is a show that also has mist. When we meet in a forest just south of Llandegla at a little after 5am, it's gloomy and grey and there's just a hint of mist around the tops of the tall conifers.

But as we begin the walk through the forest to the hide the mist gets thicker. Which is bad news for our group, particularly for the couple who have driven all the way from Portsmouth. It probably doesn't help that one of our guides feels that he has to apologise for the weather, but also to share with us how blue the sky had been on the last walk.

Not that a bit of mist deters the grouse. As we walk through a plantation of head-high conifers to the hide it closes in, but the eerie calls of the grouse grow louder and more persistent.

Written descriptions of bird calls never really work and the noises grouse make at a lek are a particular challenge. A constant is a bubbling, warbling trill that starts before sunrise and continues throughout the action like a backing track.

There are other sounds too. One is a harsh wheeze that the males make when conflict flares. I have heard it called a sneeze, but that puts a polite gloss on what sounds much more like the long drawn out clearing of a phlegmy throat.

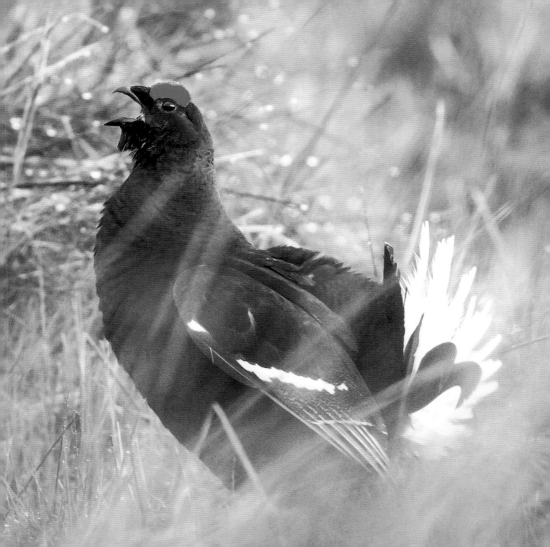

Wales has no more than a few hundred black grouse. It means that tickets for the RSPB's grouse lek walks at Llandegla can be hard to get; people will book far ahead to go to the wild stretch of moorland close to the Offa's Dyke.

So, what is a lek? From inside the hide it's hard to make out, because the grouse are some way off and getting a telescope lined up on them isn't that easy.

Ghostly shapes move in the gloom, but the patchy mist does little to help. "See that tree... go about 30 yards from that and a bit to the right... see them?"

Picking a point of reference is a challenge. There are a few stunted trees, but otherwise it's all grey-brown moorland.

The moor looks empty, then a flash of pure white catches the eye as though a light has been flicked on and off – the tail feathers of a black grouse male in his pomp.

The male black grouse, or black cock, is a handsome bird. Its glossy black plumage has a purple sheen, it has scarlet wattles like eyebrows and that petticoat of tail feathers are the sort of white paint manufacturers might call 'brilliant'.

For a moment, tail feathers are spread and angled towards the hide. Facing another male, their owners seem to be dancing.

The rivals look a little like a pair of drunks squaring up to one another outside a pub. There's menace in their stiff-winged circling, but then there's also something of Irish dance about the fancy footwork.

The word 'lek' is Swedish and means 'game' or 'sport'. What happens at a lek is that local males get together and display in a single location so that breeding-age females come by and choose a mate.

In human terms, a lek is speed dating. Not that the participants are expecting anything long-term. After mating, a female heads off and has no further contact with her mate, who makes no contribution whatsoever to the care of future offspring.

The word 'lek' is both the activity and the location; a lekking ground will often remain in use over many generations. The word is also used by zoologists as a term to describe a mating strategy and though the black grouse is the perfect example of the lekking system, it is far from being the only species to make use of it.

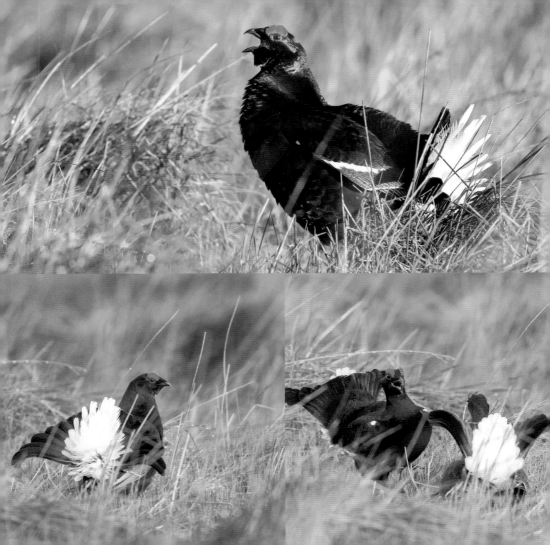

Britain's biggest grouse, the capercaillie, lives in Scotland's native pinewoods, where leks see males and females gather in early spring. Other grouse species around the world lek too, including North America's prarie chicken.

But it is also something that other birds do too, including New Zealand's night parrot, the kakapo. And one study that looked for lekking elsewhere in the animal kingdom found plenty of other species doing something very similar, including crabs, fish, flies and newts.

Watching the Llandegla lek from a distance it's hard to spot the females, although when one drops by it is clear to see how the males up the intensity of their display. A female black grouse, or greyhen, is a sharp contrast to the showy-looking males.

With its mottled buff, grey and black plumage, a greyhen is perfectly camouflaged for life on open heather country. Showy plumage is an advantage for a lekking male, but it is better for a female to be as low-key as possible.

When the time comes, she lays up to 10 eggs in a simple nest on the ground in thick vegetation, usually within about a kilometre or so (0.6 miles) of the lek. Chicks leave the nest almost immediately and can fly by their second week.

The location of the lek continues to be important when the chicks are young. At first they stay with their mother as a family group, but as they mature the young birds move on.

Males keep close to their father's home lek while the females wander a little further afield. Most go no further than 2.5 miles (4km), but a pioneering few travel as far as 11 miles (18km) from 'home'.

> Males keep close to their father's home lek while the females wander a little further afield.

The loyalty to a lek location means that moorland that loses black grouse is likely to be slow to see them return, however good the habitat may be. The moorland of north-east Wales is perfect black grouse country; they are birds of the margin between woodland and heath, needing both habitats if they are to thrive.

In summer they lek and nest in open areas, but in winter they shelter among trees. For the most part they are herbivores, relying on the buds, leaves, flowers and seeds of heather and bilberry.

Left: Male black grouse congregate at the lek under the cover of darkness and start battling just as the sun rises over the hill.

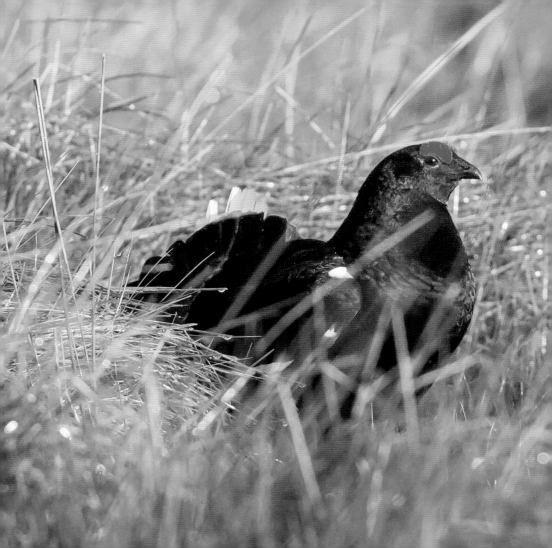

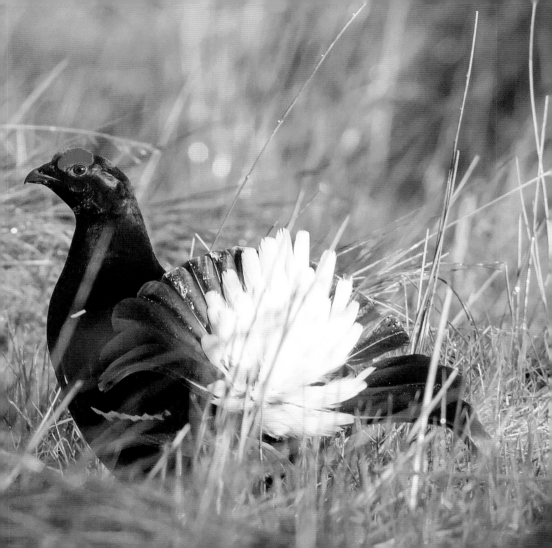

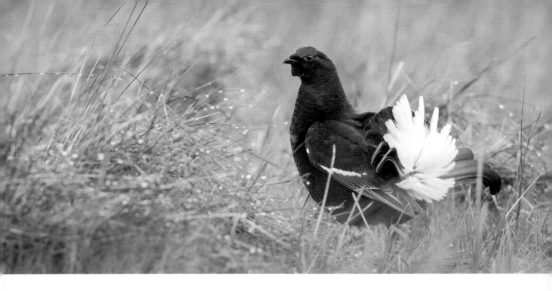

Their diet varies from season to season. In spring they favour cotton grass flower buds, moving on to flowers and grass seeds during the summer.

When bilberries ripen in July they are eaten by adults, while young chicks need protein-rich insects to grow strong. During autumn and winter grouse eat berries and grass seeds, moving into woodland when there is a fall of snow to eat buds and catkins.

Above and right: Lekking isn't just a fair weather business. Even in heavy rain the contest goes on.

The species has been in decline for at least two centuries. Records show that it was once found throughout Britain, but in *The Natural History of Selborne* the pioneering naturalist Rev. Gilbert White describes the loss from his Hampshire parish during the mid-18th century.

And the more recent history of the species has seen its steady loss as a breeding bird from other counties in England and Wales. A survey in the early 1990s estimated that the UK then had about 25,000 displaying males, but by 2005 that had fallen to nearly 5,100.

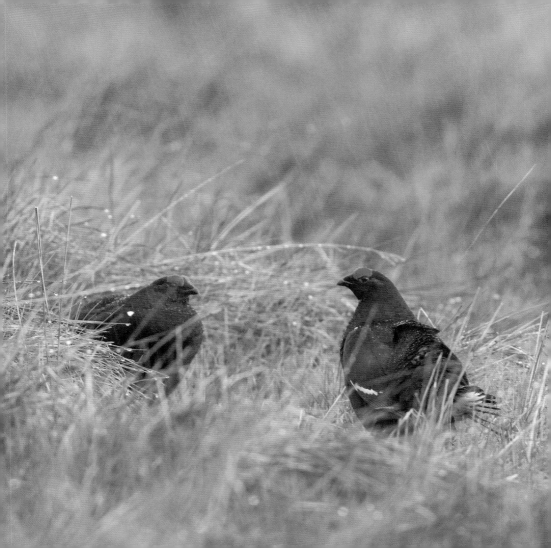

Two-thirds of the UK population lives in Scotland and there are smaller populations in both England and Wales. In Wales, the black grouse was a widespread species as recently as the early 1970s, but it is now found in a much more restricted part of the north and east.

The good news is that though the population in Wales is small, it's growing. A decade ago the Welsh population was estimated at only 200 displaying males,

Above: Black grouse walks are available to book through the lekking season. See RSPB website for details.

but in 2011 around 320 lekking males were recorded, the best count since monitoring began in the early 1990s.

Exactly why the previous decline happened is open to question. Part of the problem is thought to be that today's land-use is less mixed than it once was; black grouse do best where there is a patchwork of moor, forest and farmland.

Over-grazing by livestock may also have been a problem. Sheep eat flowering plants, which reduces the numbers of caterpillars around when grouse chicks are small.

Changes in forestry practice also have an influence. Black grouse do best where forest 'melts' into heath and seem to dislike hard-edged plantations.

Last, but not least, black grouse have a problem with fences. When startled they fly low and fast, which can result in fatal collisions with wire fences.

With so few black grouse left in Wales there is a worry that our interest in the birds could itself become damaging; that human interest disturbs lekking. So the safest way to experience the show is probably to go along to the RSPB's led walk at Llandegla, but the next best bet is to watch from a parked car.

On foot there's a chance that you will frighten the birds away, but they will tolerate a parked vehicle as long as it's at least 100 metres away. It is best to turn up before dawn and sit with your car's engine off until lekking has wound down, which is usually around two hours after sunrise. And, try to choose a day without mist.

Visit

Coed Llandegla (grid ref. SJ 227 520) is owned and managed by the forestry company UPM Tilhill, which works with the RSPB to conserve black grouse. Lek walks at Llandegla are run by the RSPB (rspb.org.uk/datewithnature) and are led by its volunteers.

Also

Ospreys probably bred in Wales in the Middle Ages – the coats of arms of West Glamorgan feature the fish-eating bird of prey, but the species was lost as a breeding bird. That changed in 2004, when one pair decided to raise young at Glaslyn, Powys. The osprey comeback continues and one of the best locations to see the birds now is at Glandyfi (dyfiospreyproject.com), near Machynlleth, where Montgomeryshire Wildlife Trust created an artificial nest for them. Ospreys spend their winters in Africa then head back to Britain in spring, with the Glandyfi birds usually turning up in mid-April.

May

5. Singing the blues
Castle Wood, Llandeilo, Carmarthenshire

Castle Wood is part of the Dinefwr Estate, which is on the western edge of Llandeilo.

Timing is everything; the arrival of spring shifts from one year to the next, but by mid-May its full effects can usually be felt. Then a good alarm clock is a must too; if you're going to experience the new season at its best you need to be out of bed before first light.

At just before 5am at the entrance to Castle Wood, it is surprisingly cold given the month and a navy blue sky is getting lighter, edging towards Air Force blue. To the east – somewhere above where the market town of Llandeilo is, presumably,

still mostly tucked up warm – the horizon has a deep, red glow.

Not far away, in undergrowth near to the footpath into the wood, a robin is singing. Its clear, sharp notes seem surprisingly loud in the pre-dawn quiet.

The dawn chorus really is one of the delights of spring and the experience is most intense in May at somewhere like Castle Wood. The daybreak 'performance' can be impressive in March and April, but by May the volume and variety of song peaks as birds that visit Wales to breed during the summer arrive and add their voices to the mix.

Ancient woodland guarantees something special. The woodland at Dinefwr is home to many species, including nuthatches, treecreepers and all of the three British woodpeckers – green, great spotted and lesser spotted. Summer visitors include willow warblers, chiffchaffs, redstarts and pied

Right: A highlight of the spring is the arrival of the beautiful and colourful redstart.

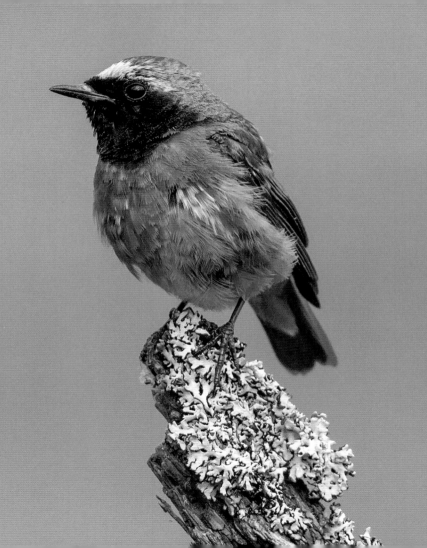

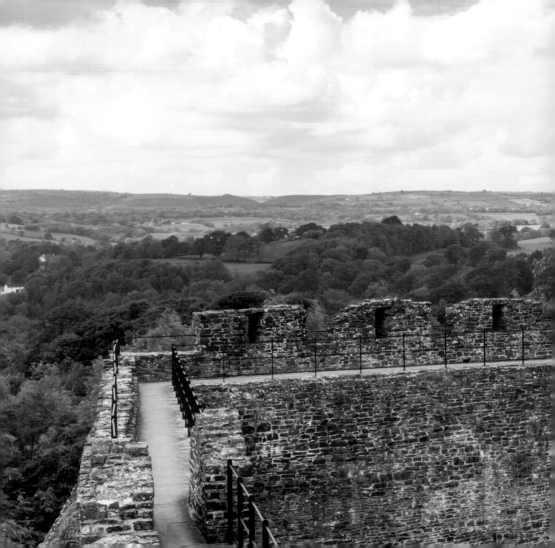

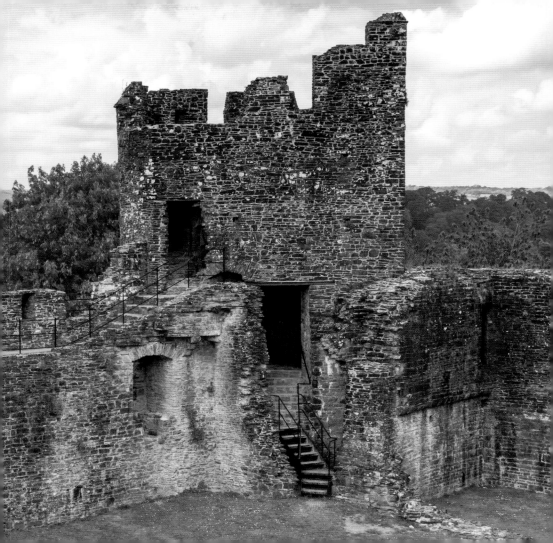

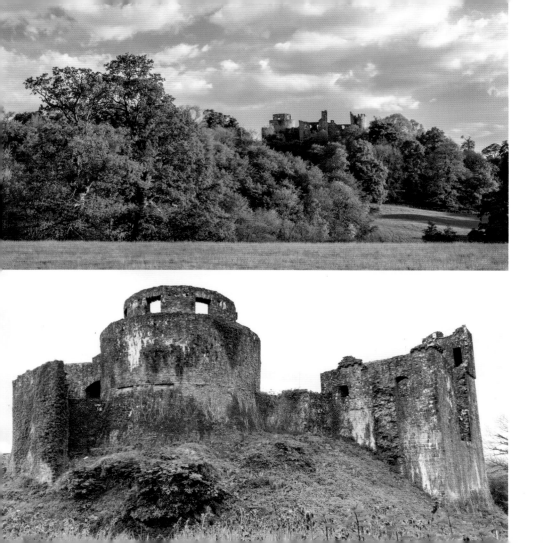

flycatchers, which arrive in April.

Birds sing at dawn for two reasons. It's mostly about territory; by singing at sunrise birds tell other members of their species that they have lived through the night and that their patch remains fully occupied.

Song is also about attracting a mate. A male that has the energy to belt out a strong, clear song will be seen by prospective mates as a good choice as a potential father.

Early morning is the perfect time of day for birds to sing because it is quieter at dawn, so the notes of a song carry further. Also, when light levels are low searching for food is difficult and there's a greater risk of falling foul of a predator, so singing is a more sensible use of the time.

Wales is a well-wooded country. All woodland is a useful wildlife habitat, but some is more valuable still because of its age. The communities of plants and animals in woods that are classified as 'ancient' have been centuries in the making.

To qualify as 'ancient', a woodland obviously needs to have been under continuous cover for a very long time. When Britain's ancient woods were first

mapped in the 1980s, the date chosen to be the trigger was 1600, so a wood has to be a little over 400 years old to earn the status.

The most recent inventory of woodland in Wales gives the nation's total area of ancient woodland as around 95,000 hectares (235,000 acres). To put that into context, it represents nearly a third of all the woods in Wales.

Castle Wood easily earns its place. It is part of the Dinefwr Estate and at the heart of the wood is the medieval Dynevor Castle, from which it gets its name. The castle stands on a hilltop close to the edge of the wood and high above the River Towy.

According to legend, the ninth-century ruler Rhodri Mawr chose to have a seat at Dinefwr when he created the Principality of Deheubarth. It went on to become the principality's Llys, or court, and the centre of a government that controlled

Left: The castle grounds and parkland at Dinefwr come to life in the spring months.

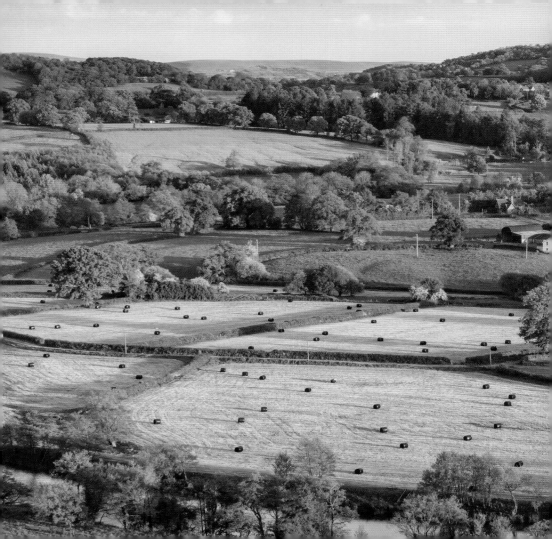

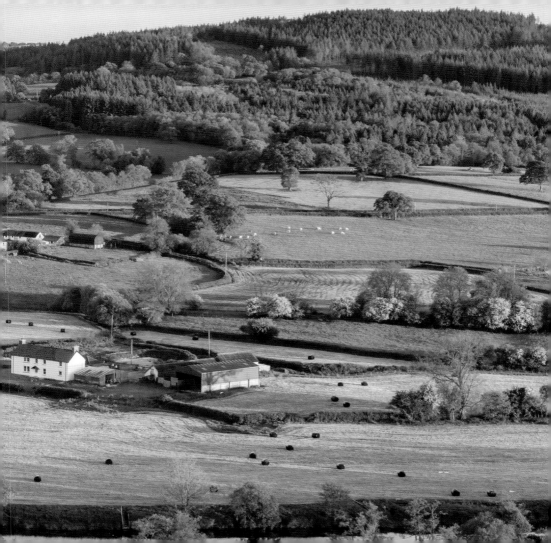

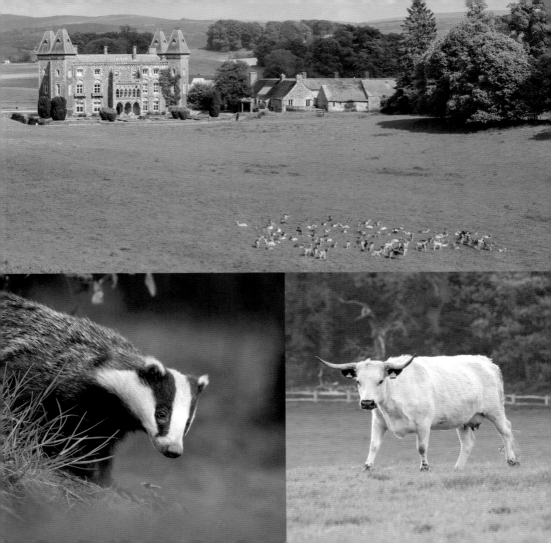

much of Wales, including Pembrokeshire, Carmarthenshire, Ceredigion and the south of Powys.

Woodland was usually cleared around medieval castles to provide good sight lines, but it seems not to have been the case at Dinefwr. The 12th-century traveller Gerald of Wales (also known as Gerallt Gymro or Giraldus Cambrensis) wrote: "The Tywy... passes by the castle of Llanymddyfri, and the royal palace and castle of Dinevor, strongly situated in the deep recesses of its woods."

Castle Wood is a mixed broadleaf woodland. Oak, ash, beech and sycamore share space with some species that are not as typical of west Wales, like sweet chestnut and horse chestnut – trees that may possibly owe their presence to an experiment in forestry a generation or two ago.

Approaching the castle the path through the wood passes below beech trees, whose fresh, soft leaves shine in morning sunlight. Horse chestnuts leaves are already darker, but on the oaks and ashes buds are only just beginning to burst.

Two rabbits come bursting out of the undergrowth. One disappears back into

Left: Fallow deer and White Park cattle graze the parkland and, at dusk, badgers forage at the edges of woods.

the green, but the second freezes – then stamps a back foot hard on the ground to let its community know that a human is coming their way.

Ancient woodland is an incredibly rich, diverse habitat and Castle Wood is managed in a way that supports that diversity. Dead wood is particularly important and fallen trees and tree boughs are allowed to rot where they fall.

Decaying wood allows nutrients to be released and returned to the soil and supports an army of organisms whose purpose in life is to be decomposers. They include beetles and other invertebrates like woodlice, as well as many species of fungi.

On either side of the path to the old castle there's an explosion of lush new growth. New shoots are appearing on brambles and there are fresh fern fronds everywhere.

Closer to the castle the way is steep and the surrounding trees are veterans. Huge ash trees stand among the oaks, barrel-chested like their neighbours but taller.

Below the castle wall a single swallow chimes up its angry alarm call and dive-bombs a passing sparrowhawk. The hawk flies on low and slow; it seems untroubled by the confrontation, but the smaller bird has its way because the predator keeps moving.

The castle ceased to be at the heart of the estate at the end of the Middle Ages. England's King Edward I disposessed the Rhys dynasty in the 1270s and they had to wait 200 years before Dinefwr came back to them after the Battle of Bosworth Field.

When Henry Tudor arrived in Wales in 1485 to challenge the kingship of Richard III, Rhys ap Thomas gambled by throwing his lot in with Henry. It was a gamble that paid off and Rhys was knighted by the new king, who also restored his estates.

The estate's focus since the 1660s has been Newton House, sometimes still called the New Castle, while the grounds were remodelled in the late 18th century in the fashion of the time. At around

Above and right: Dinefwr's bluebell woods are a delight to the senses.

that time a summer house was built on top of the round keep of the old castle, presumably so that family and guests could enjoy the views. And, on a May morning, those views are striking.

Looking towards Newton House your field of vision is filled by surrounding woodland. It has an unexpectedly exotic feel to it, because the springtime tree canopy is a mix of surprisingly vivid colours. There are shades of lime green so bright in the early sunshine that they seem almost fluorescent and the red-brown of new leaves fresh from bursting buds.

And there's a sweet scent on the air too, because May is bluebell month. At the castle's outer ward the flowers grow among the grass below the walls and there are more among the hazels on the steeper slopes.

But the bluebell experience is at its most intense further on towards Newton House, where the wood is dominated by fine, old beech trees. There, bluebells carpet the woodland floor.

The brief flowering of the native bluebell (Hyacinthoides non-scripta) is a glorious moment across Wales. Bluebells occur throughout much of western Europe, but rarely in the numbers and densities that can be seen in the best Welsh bluebell woods like Castle Wood.

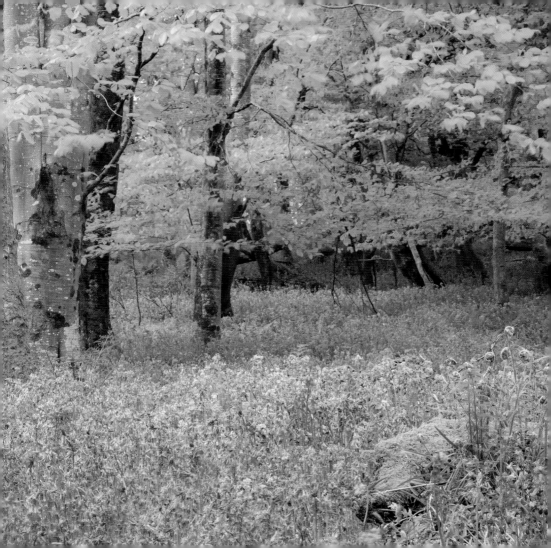

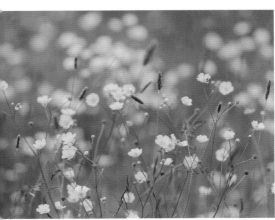

Plants struggle to survive in the gloom under mature beech trees in leaf, but the bluebell has evolved to thrive in the subdued light. They do it by living on fast-forward.

The plants are beginning to come into flower when trees are just starting to come into leaf and within weeks they have set seed. By early summer, flower stalks whither and dry.

But during the time before the tree canopy shuts out the light, photo-sensitive cells in bluebell leaves are working flat out. They turn the sun's energy into sugars to store in the plant's bulbs –

enough is stored away in a few weeks to keep each plant alive throughout the rest of the year.

Where they are left to their own devices, like at Castle Wood, bluebells spread to carpet the huge areas. The haze of colour and their sweet scent overwhelms the senses and, with the dawn chorus, sets you up for the day – and a really good breakfast.

Visit

Castle Wood (grid ref. SN623223) is managed by the Wildlife Trust of South and West Wales (www.welshwildlife.org),

while Dinefwr Estate is a National Trust property (www.nationaltrust.org.uk/dinefwr). Both the wood and old castle are open to the public and free to visit.

Also

You can enjoy the dawn chorus and see bluebells in bloom at woods throughout Wales. Two of the best to visit are Coed Cefn in the Brecon Beacons National Park at Crickhowell, Powys (grid ref. SO226 186, visitwoods.org.uk) and at Coed y Felin (SJ192 677, northwaleswildlifetrust.org.uk), near Hendre, Flintshire.

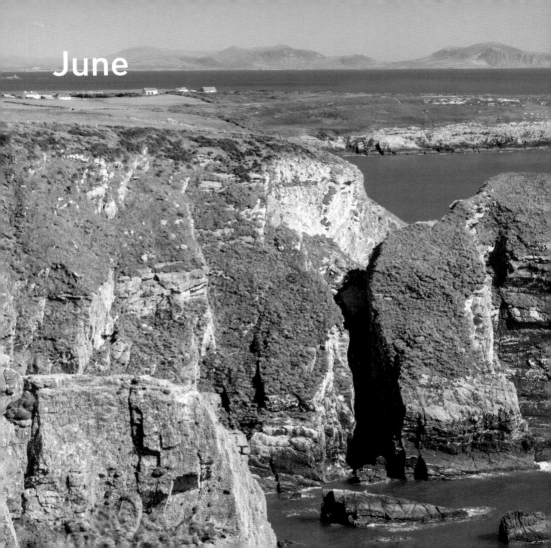
June

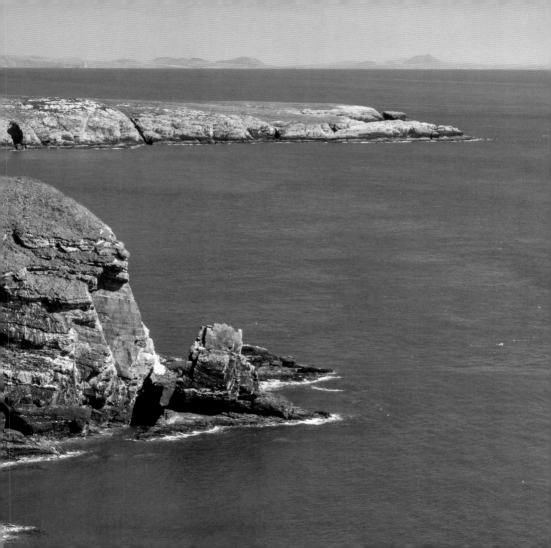

6. City living
South Stack, Holy Island, Anglesey

At the far west of Holy Island, the South Stack reserve is 2.5 miles (4km) from Holyhead.

South Stack has a marvellously out-of-the-way feel to it. It's at the far west of Holy Island, which itself forms the far western corner of Anglesey.

Looking out to the horizon I am fairly sure I can make out the grey-smudge outlines of the Wicklow and Mourne Mountains in Ireland. And my mobile is certain that it has crossed the Irish Sea – it's offering to connect me to an Eire network.

In other months South Stack can be quiet, but for a few weeks in early summer that all changes. From May to July South Stack is buzzing with activity, because that's when around 9,000 seabirds move in to rear another year's young on its sheer sea cliffs.

When it comes to numbers, South Stack cannot compete with Pembrokeshire's islands, especially Skomer. For example, at South Stack you will count the puffins you see by the dozen, while Skomer has them in the thousands.

But South Stack is very accessible. There's no boat required for a visit and it's only a short walk from the reserve's visitor centre to the cliff edge viewpoint.

In June, its seabird colony is at its busiest and it's also the peak time for visitors. On a sunny weekend you can find yourself among a firing squad of birders, all with binoculars, telescopes and cameras focused on cliff ledges packed with birds.

On a bright morning the blue-green seawater seems as clear as glass in the

Right: South Stack lighthouse has been fully automated since 1984.

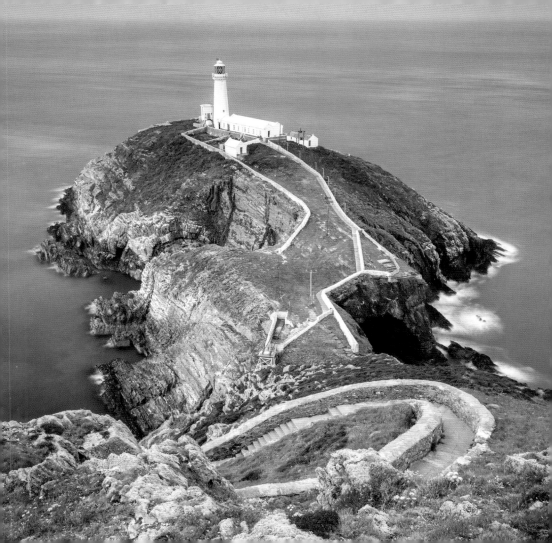

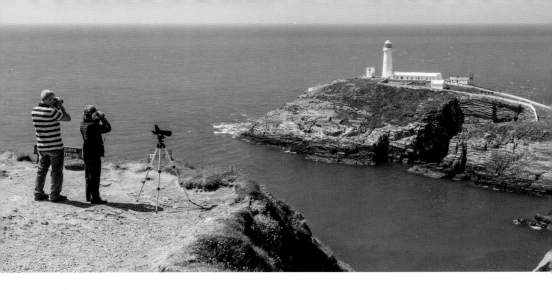

shelter of South Stack, but away to the west the tidal flow is kicking up surf. At the cliff edge there is thrift, or sea pink. By mid-June its flowers are mostly beyond their best, faded and crisped by the sun, but here and there a few are still a rich, vivid pink.

Below the watchers' viewpoint is what amounts to a seabird high-rise. Thousands of birds jostle for valuable space on every rock ledge, where their

Left: The island and cliffs come alive in the summer months with thousands of seabirds.

eggs are laid and chicks are raised.

For the human observer the 'city' can overload the senses. The din of bird calls, the constant movement and the smell of droppings and of rotting fish all add together in an overwhelming way.

So much is going on. Birds are everywhere; they fly in all directions or rest on the surface of the water in sociable groups.

The soundscape is really something: the sea, the wind and the constant calls of birds. In amongst the familiar cries of gulls there's the reedy, Mr Punch cackle of guillemots and the weird growl of the razorbill, which seems more amphibian than bird.

At the centre of it all is the lighthouse. As far back as 1645 seafarers were demanding a lighthouse for this part of the coast. A petition was sent to London, but the request was dismissed as an unnecessary expense.

In the 1800s a seasoned mariner called Captain Hugh Evans took up the cause again, approaching ship owners and merchants to ask them to support the cause. Evans failed at first to convince Trinity House, Britain's lighthouse authority, but finally got his way in 1808.

Building a lighthouse on tiny South Stack, or Ynys Lawd, must have been a challenge. The islet is just a stone's throw from the

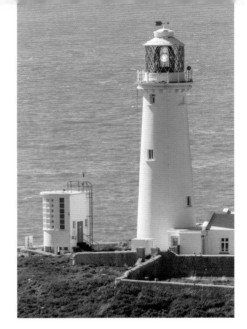

mainland, but strong currents must have made it difficult to land materials from the sea, while access from the land involved negotiating the steep cliff.

As a result, much of the building stone was quarried from the island itself, although limestone from eastern Anglesey was also used. The lighthouse was in use for five years before a rope bridge was built for the keepers; it was replaced by the first metal bridge in the late 1820s.

Life for keepers and their families at South Stack must have seemed good compared with that endured at other Trinity lights, many of which were on remote islands. But it was not without its dangers; in 1859 one keeper was killed by falling rocks as he made his way down the lighthouse steps during a storm.

It wasn't until the 1930s that the authorities decided to re-classify South Stack Lighthouse as a 'rock station', which meant that keepers were not allowed to have their families with them. The last keepers left their rocky island in 1984 when the light became fully automated.

The other man-made landmark on this stretch of coast is Ellin's Tower, which the RSPB uses as a viewpoint for visitors. With its crenellations it looks as though it has stood on its cliff-edge site for centuries, but it is actually comparatively recent – it was built in the 1860s as a summer house for Ellin Williams, the wife of the local MP William Owen Stanley.

Without the lighthouse, South Stack would not be such a good birding location. It offers visitors so many different perspectives of the nesting birds – or at least its steps do.

For obvious reasons, birdwatching at cliff-face seabird colonies usually offers just two options – from the top looking down, or in a boat looking up. But the 400 steps that zig-zag down from the clifftop to the lighthouse's bridge mean that birds can be seen from 400 differing viewpoints.

It offers a great opportunity for a close-up view of South Stack's auks. Everyone can name at least one auk – the puffin, but at South Stack you can see two other members of the auk family too, the guillemot and the razorbill.

The rounded body shape and large, coloured bill makes the puffin easy to spot, but from a distance razorbills and guillemots are harder to tell apart. Both look a little like small penguins, but if you take time to look at a mixed group the two species are easy to identify.

Razorbills have a deeper beak and black and white plumage, while guillemots have sharp, pointed beaks and the feathers on their backs, wings and heads are a very dark shade of brown. A minority of guillemots are also 'bridled', that is they have a thin white line around the eye and behind it.

The auks have lots in common, but each species has preferences and they choose different zones on the cliff face. At South Stack, puffins are heavily outnumbered

Right: Chough, rock pipit, guillemot and puffin; just a handful of the bird species on offer at South Stack.

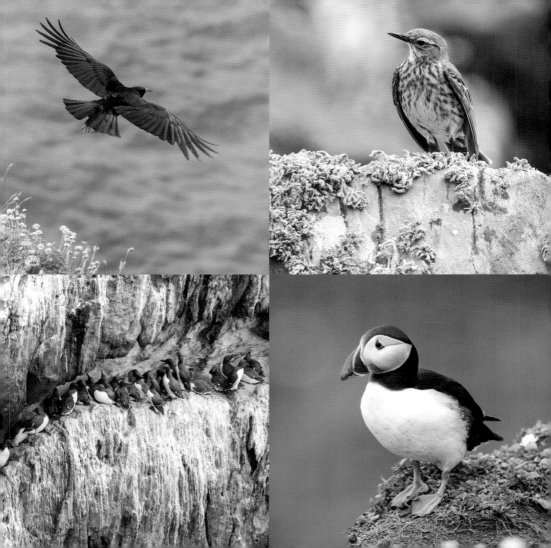

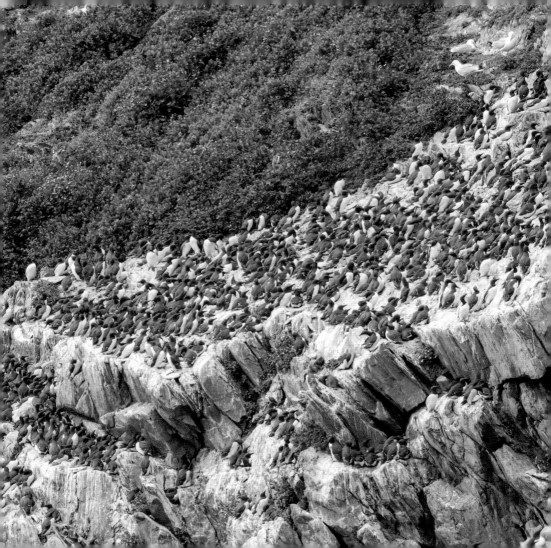

by guillemots and razorbills, but can be spotted if you look at the few greener areas on the cliff faces. Where there's soil they will burrow.

Puffins are remarkable birds. That striking beak looks comical, but it's also a multi-tool bill; it's an effective digging implement, will hold fresh-caught sand eels by the batch and plays an important role in pair-bonding too (at times you will see mates rubbing beaks).

The beak is at its most eye-catching in June. By August, when puffins return to the sea, the colourful outer plates fall away.

The puffin breeding season splits neatly into two phases. Once the female lays her single egg (usually in mid-June) it takes six weeks to incubate and then, when it hatches, the chick has to be fed for six weeks.

During those six weeks pufflings are waited on by attentive parents, but by early August everything changes. Adult puffins leave their breeding colonies, abandoning the youngsters in their burrows.

For about a week they survive on their body fat, but eventually hunger prompts

Left: Guillemot eggs are conical, which makes them less likely to roll off narrow cliff ledges.

the pufflings to leave their nests and head for the sea.

A young guillemot's start in life seems much more precarious. Where puffins opt for the personal space that a burrow guarantees, guillemots choose a communal lifestyle packed together on cliff ledges that are often just inches wide.

Packed together, the birds seem to spend most of their time squabbling. Those pointed beaks get plenty of use.

A guillemot egg is laid onto bare rock. It's large and pointed at one end, but flat at the other – the strange shape may make it less likely to roll, an advantage in the scrum of birds.

You will rarely see a guillemot egg. The parent doing the incubating balances it on its feet and then settles down on top of it.

Young guillemots leave their ledges at just three weeks old – and long before they are ready to fly. That is why guillemots raise their young on cliffs that offer a straight drop into the sea.

The youngsters normally jump at night when they are less likely to fall victim to predators. Once they are in the water they paddle off out to sea and it is a few weeks before they are able to fly.

Razorbills are more adaptable about where they nest. They will use sheltered ledges, but also make use of rock crevices and spaces under boulders.

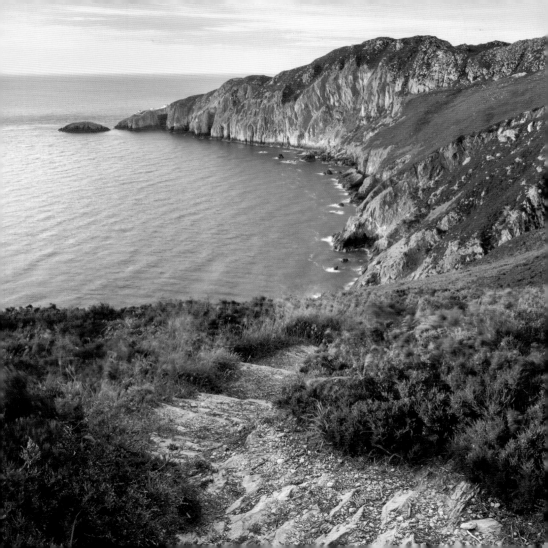

Like guillemots, young razorbills head for the open sea well before they have mastered flight. On the water, they are fed by both parents until they can fend for themselves.

It can be engrossing to watch all the activity around the colony. Seabirds make up the main 'cast' of the show, but there are other birds to look out for too. For example, peregrine falcons nest high on the steepest cliff face, while rock pipits forage among the wildflowers that grow wherever their roots can find a little soil to grow in.

But it would though be a mistake to put all the time you have at South Stack over to the cliff colonies. The heathland that extends from the clifftops to Holyhead Mountain – the largest area of coastal heath in northern Wales – is worth taking time to explore as well.

Stunted by the wind, the gorse is rarely more than knee-high. The tops of the bushes make a perfect perch for stonechats and their distinctive 'tap-tap' calls carry across the rocky hillsides.

If you are very lucky you may spot a basking adder as you walk, or see a common lizard moving through short-cropped grass. But every visit should finish above the cliff colony.

Visit
South Stack is an RSPB reserve (grid ref. SH 206 819). It is open all year round and is free to visit. There is a visitor centre and cafe at the car park. Find out more at www.rspb.org.uk/reserves

Also
June is the wildflower month. At Kenfig (SS793 817, naturalresourceswales. gov.uk), near Pyle, orchids are in bloom in the dunes, including the rare fen orchid. In Snowdonia, it's the month to look for those flowers that grow just in the high mountains and that are classed as arctic-alpine plants, like moss campion, roseroot and, if you are very lucky, the Snowdon lily. A good place to look is Cwm Idwal (SH642 590, naturalresourceswales.gov.uk).

Left: The cliffs and heathland at South Stack are full of colour in early summer.

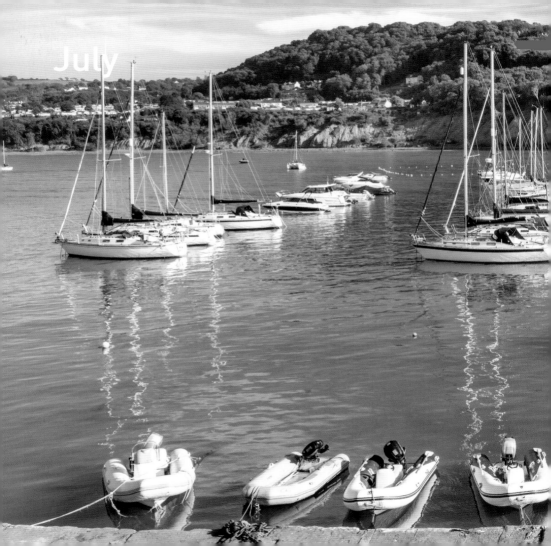

July

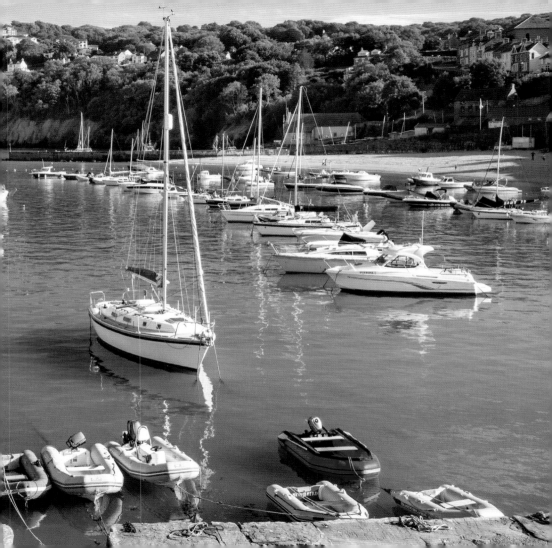

7. Watching water
New Quay, Ceredigion

Just off the A487 coast road, New Quay is at the heart of the Cardigan Bay Special Area of Conservation.

Like any sort of animal-watching, dolphin-spotting is something of a lottery. There's never a guarantee of success.

Our day at New Quay is a perfect example. We had spent half of it cruising along the coast on a wildlife trip boat, but had seen nothing.

Or at least, no dolphins. Seabirds are everywhere. Cormorants paddle along on the swell as our boat chugs past, fast-flying razorbills skim past on their way to sea cliff nests and, further out, we see ice-white gannets 'commuting' to their fishing grounds.

Right: The first sight of dolphins is an exhilarating moment.

But there's no sign of dolphins, despite the fact that Cardigan Bay is home to one of only two resident bottlenose dolphin groups around the British coast (the other one is Scotland's Moray Firth). The inshore area around New Quay is the hotspot for sightings, but the bay is large and there's plenty of space for a population of only around 130 individuals to lose itself in.

So, as we disembark there is an air of disappointment. As I walk away towards the car park I am already planning a second outing.

Halfway along Rock Street, something stops me in my tracks. There's an oddity in the mix that makes up the afternoon soundscape, something added to the gentle swash of waves on Dolau Beach, the drone of traffic and the clamour of squabbling gulls.

It's cheering. Close to the harbour wall there's a dolphin boat (not ours)

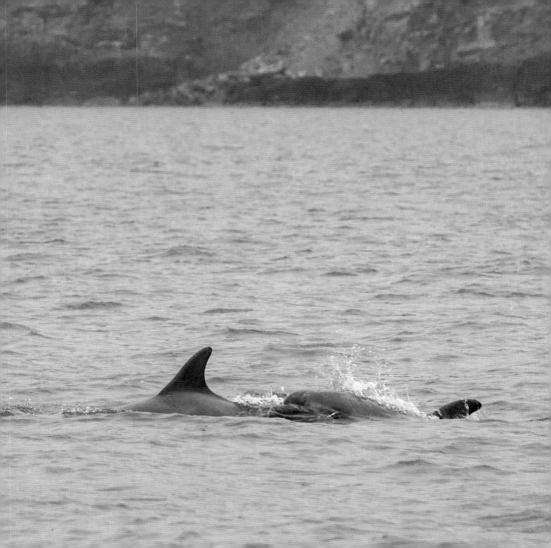

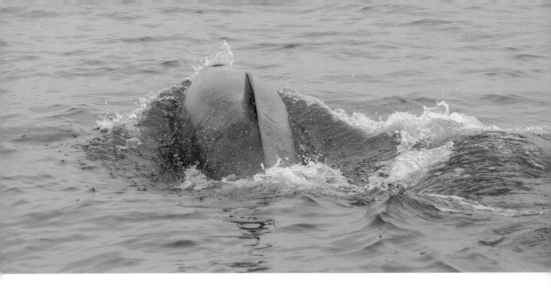

on the water, stationary and listing. Its passengers are crowded along one side.

Then there's another cheer as, less than a stone's throw from them, a dolphin leaps clear from glass-calm sea. And I stand and watch as, for more than ten minutes, the dolphin jumps and twists time and again, just as if it were enjoying the reception its audience is giving to its performance. It's an experience that

Right: New Quay is a fabulous setting for dolphin-watching. Dolphins can be seen throughout the year and are often spotted from the harbour wall.

highlights two things: that you don't need to go out on a boat to go dolphin-spotting, and that there's a good chance that if you wait they will come to you.

People love cetaceans – that's dolphins, porpoises and whales. It's an interest that has driven the growth of a worldwide cetacean-watching industry.

But there's often an assumption that to see whales or dolphins you need to take a long-haul flight. In fact, the waters around Britain have a rich cetacean fauna and Cardigan Bay offers one of the UK's best opportunities for a dolphin encounter.

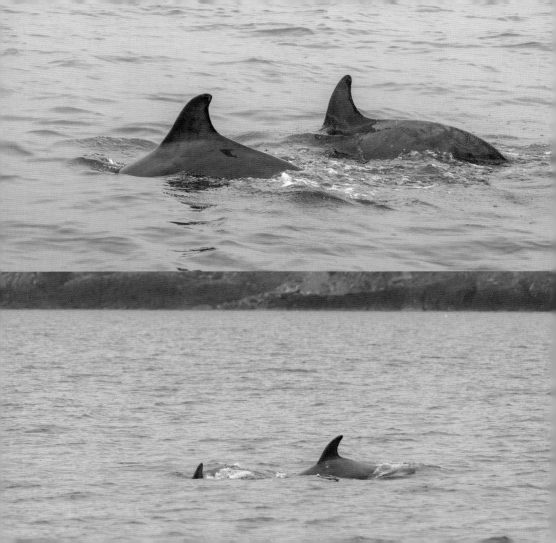

In all, 11 of Europe's 28 species are regularly seen in UK waters. They include four species of dolphin, the tiny harbour porpoise and two giants – the fin whale and the sperm whale. In Cardigan Bay, rare visitors include humpback whales and orcas (killer whales), but both harbour porpoises and bottlenose dolphins are present all year round.

"In many ways, the bottlenose dolphin is the archetypal dolphin," writes the cetacean expert Mark Carwardine, "star of television programmes, films and marine parks, the world over, it is probably the species most people imagine when the word 'dolphin' is mentioned."

Bottlenose dolphins are extremely adaptable and they occur in seas around the world. They vary in size and colour from place to place and those that live in Cardigan Bay are bigger than those that live closer to the Equator – their size helps them survive in colder waters.

Highly sociable, bottlenose dolphins live together in groups called pods and hunt together. They often work as a team, chasing shoals of fish at speed.

Why Cardigan Bay? An old folk story

Left: Dolphins have excellent eyesight and hearing as well as the ability to use echolocation to pin-point the exact location of their prey.

offers a clue. It tells of a time when low-lying land extended far to the west, well beyond the bay's present coastline. The fertile farmland, known as Cantre'r Gwaelod or Maes Gwyddno, was protected by a bank with a sluice gate.

When the gate was accidently left open, the sea rushed in. The Cantre'r Gwaelod story is one of many inundation legends from around the world, but it may have some grounding in fact. At the end of the last Ice Age, melting ice caps resulted in a sea level rise of around 100 metres (330ft).

The first 200 metres of depth is called the sunlight zone and is full of life.

Whatever the truth of the story, it does help anyone standing on the bay's shore to visualise the undersea environment that dolphins inhabit. A relatively large and sheltered area of sea, it shelves gently and even 40 miles (64km) out from the coast is no more than 50 metres (164ft) deep. The sea is zoned by scientists based on how much light penetrates the water; the first 200 metres of depth is called the sunlight zone and is full of life.

In Cardigan Bay, the nature of the seabed adds a variety of niches – like sandbanks, reefs and sea caves – that

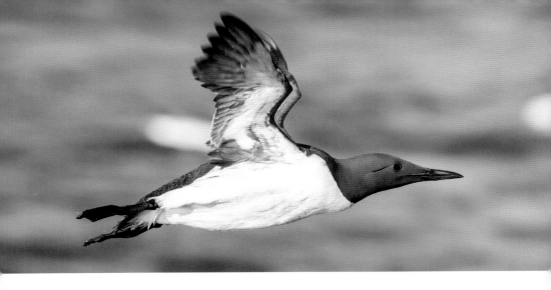

different plants and animals can occupy. It all adds up to a rich hunting ground for the bay's dolphins. They can find plenty of the foods they prefer – crustaceans, molluscs and fish like mackerel and mullet.

The bay's dolphin community is so important that they have been given their own marine nature reserve, the Cardigan Bay Special Area of Conservation (SAC). It is one of a network that protect Europe's most important wildlife sites.

The reserve takes in 28 miles (45km) of coast between Ceibwr Bay in north Pembrokeshire and Aberarth in Ceredigion, and it also extends more than 12 miles (20km) out to sea. In all it takes in around 1,000km square of open water.

Though primarily created for dolphins, the reserve's existence is also a recognition of how amazingly rich the Cardigan Bay ecosystem is. The importance of its reefs, sandbanks and caves are recognised, as is the international conservation importance of its Atlantic grey seals and its lampreys.

Whether you choose to do your wildlife-watching from the clifftops or from a boat, there's a good chance that you will see a seal. Each autumn, more than 60 seal pups are born on beaches along the rocky

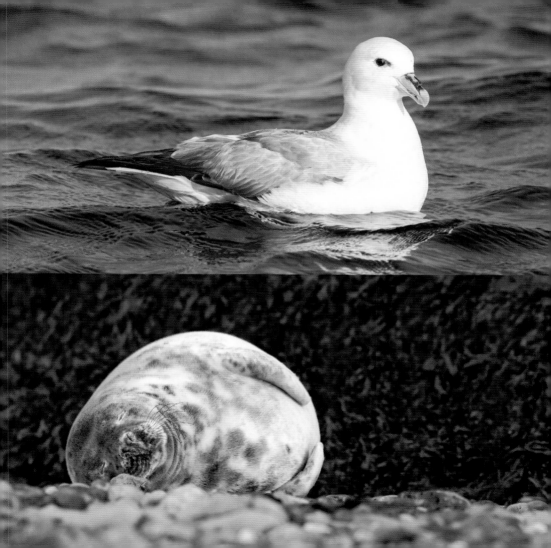

shoreline, many of them between the Ynys Lochtyn peninsula, near Llangrannog, and New Quay Head.

You are far less likely to see one of the two species of lamprey that occur within the reserve. The river lamprey (Lampetra fluviatilis) and the sea lamprey (Petromyzon marinus) are primitive fish that are very similar to fossil specimens from the late Silurian and Devonian periods, around 450 million years ago.

During the early stages of their lives lampreys lie buried in river silt, but later they migrate to estuaries and to the sea. There they live as parasites of bigger fish, which they cling to using sucker mouths.

You will probably not encounter a lamprey, but you can have a close look at the reserve's undersea biogenic reefs. At low tide there are a number of places along the coast where reefs are exposed near to the low water mark, including Aberaeron, New Quay's Dolau Beach and Llanina Point.

You have to know what to look for, because, from a distance, the sharp-edged, grey reef mounds can be hard to make out among rocks in the inter-tidal zone. Closer to, their surface is pitted

with small holes and looks a little like honeycomb.

The mounds can be as much as half a metre (20in) high and are termed 'biogenic' because, like coral, they are built by living organisms. In Cardigan Bay, the reefs are the work of honeycomb worms (Sabellaria sp.), which cement together sand and shell grains to make tube-shaped shelters to live in.

Over time, generations of worms add their tubes, creating large structures and gluing together beach pebbles and rocks too. Just like corals, the Sabellaria reefs teem with life because they offer a surface for seaweeds to anchor themselves to and food and shelter for all sorts of undersea animals. It all adds up to a perfect living space for dolphins and for lots of other marine species, like the porpoises, seals and seabirds.

What can a would-be dolphin-spotter do to maximise their chances? The peak dolphin months at New Quay are April to September, but personally I recommend June or July. The early summer is quieter on the coast than the peak holiday months later in the year.

And there's the added interest of the many seabirds that breed along the coast in early summer. For example, razorbills are busy feeding chicks in late June and early July, but leave the bay by the end

Left: Fantastic rock faces near New Quay are great places to find nesting sea birds.

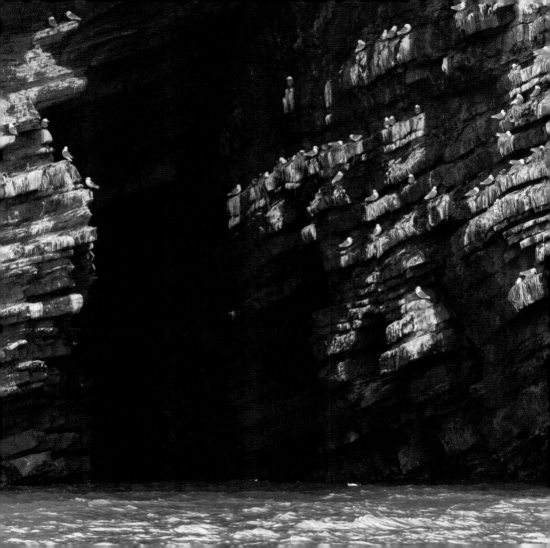

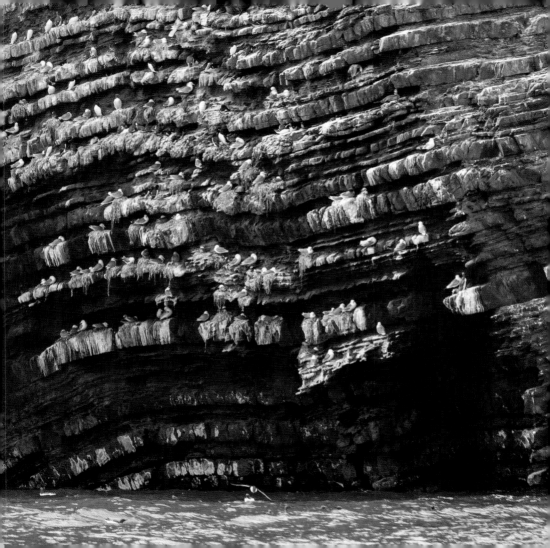

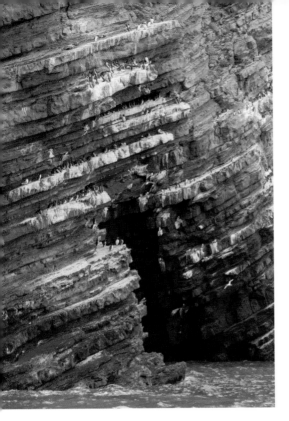

However, the main focus for sightings is the area around New Quay at the southern end of the Ceredigion coast.

Dolphins can be seen at any state of the tide, but especially around, or just after, high tide. And weather is a factor too. A calm, flat sea makes it much easier to spot dolphin activity, especially if you are patient and spend time scanning the water (preferably while wearing Polaroid sunglasses).

Our return trip was more successful. On a grey morning and in a slightly choppy sea we eventually caught sight of a single dolphin just off the village of Aberporth.

The boat's captain killed the engines and we watched. For a time it worked to and fro, appearing above the water's surface briefly before disappearing for minutes at a time.

It never came any closer to us than 250m (820ft) and gave every impression of being totally absorbed in its foraging. In time, it disappeared.

As the boat turned for home it felt as though we had had starter without enjoying the main course. But within minutes, two sleeker, smaller dolphins appeared alongside, shadows just below the surface.

The pair stayed with us for most of the journey back to New Quay, keeping cameras busy. Well worth the wait.

of July and are gone until the following spring.

Dolphins can be seen throughout the bay and wildlife boat trips operate from a number of coastal resorts, including New Quay, Aberaeron and Aberystwyth.

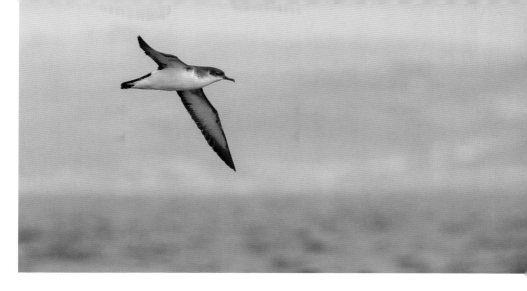

Visit

New Quay's harbour (grid ref. SN390598) is a good spot for some land-based dolphin-watching and is also an embarkation point for wildlife cruise boats. Find out more about the bay's wildlife, and boat trips, at the Cardigan Bay Marine Wildlife Centre (www.cbmwc. org) on Glanmor Terrace. The SAC website is www.cardiganbaysac.org.uk.

Above: Whilst out on the boat, keep an eye out for the great ocean cruiser – the Manx shearwater.

Also

July is perfect for dragonfly-watching. At Ynys-hir (SN 682 961, rspb.org.uk), near Machynlleth, the mix of habitats is just right for dragonflies and a total of 24 different species have been recorded. At Cors Caron, near Tregaron, you will see clouds of dragonflies and damselflies on sunny days on and around the huge peat bog from the boardwalk. Another good location is Dolydd Hafren (SJ 201 000), near Welshpool, which is on the River Severn.

August

8. Bump in the night
Skokholm Island, Pembrokeshire

 Skokholm is 2.3 miles (3.75km) west of the Pembrokeshire coast and 1.5 miles (2.5km) from Skomer Island, its better-known neighbour.

Skokholm has to be the strangest place to spend a night in all of Wales. For the full effect you need a dry, moonless August night and patience – the main event doesn't really begin until well after midnight.

If all the conditions come right, a night walk on the island is an unforgettable experience. That's because although you will be sharing your temporary home with no more than 10 other people, the island 'belongs' to thousands and thousands of birds.

For a few months each spring and summer, Skokholm comes to life as seabirds of all kinds raise their young there. By day, a visitor can watch many of them – the gulls, puffins, razorbills and guillemots that nest around Skokholm's rocky coast.

But there's a noisy nightshift that only begin to turn up after dark – the thousands of Manx shearwaters that nest on Skokholm. By day there are plenty of shearwaters on the island, but they are hidden in the many breeding burrows that honeycomb the island's surface.

At night, food deliveries arrive. Shearwaters that have been foraging far from Skokholm gather out at sea and then come in to feed hungry chicks.

For a first-time human visitor the island's night-life comes as something of a surprise. You will have been warned that when shearwater hour comes around things will get a bit noisy, but by midnight it's a constant clamour.

Right: Hundreds of Manx shearwaters gather as the sun sets.

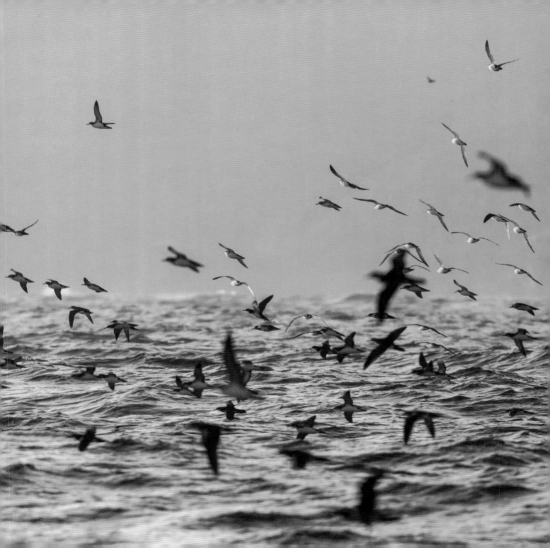

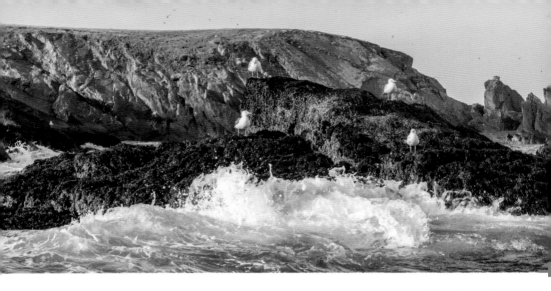

It is worth taking a moment to describe a Manx shearwater. Shearwaters are related to albatrosses and, though smaller, they are built along the same lines.

They eat fish (typically herrings, sardines and sprats), are only about the size of a pigeon, but have long, slender wings that they hold straight as they skim low and fast over the sea. They get their name from their habit of cutting, or shearing, through wave tops.

It's something of a mystery how the birds manage to arrive at just the right burrow as they turn up in the dark.

They come in at speed before slamming on the brakes at the last moment and thudding to the ground at, or nearby, the burrow entrance.

Part of the location process is about communication. In the darkness the birds are constantly calling; walking at night you hear them all around in the blackness – even from the ground below your feet.

How to describe a shearwater's call? The best I can come up with is that it's like someone tuning up leaky, wheezy bagpipes ready to play. There's a story that mariners used to give Skokholm a wide berth because they took the strange

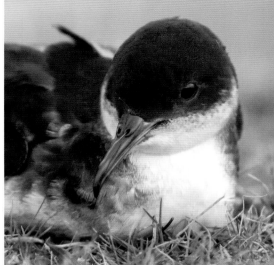

sounds of mid-summer to be ghosts.

Vikings visited the coast of Wales and the names of many landmarks have Norse origins. The Pembrokeshire islands of Ramsey, Grassholm, Skokholm and Skomer all have these Viking names.

It's a fair bet that the Skokholm that the longships visited looked rather different to the treeless one that visitors explore today. Their name for the island means the 'wooded island' (one which it shares with Sweden's capital, Stockholm).

Where others heard ghosts, the Viking travellers heard trolls. The Isle of Rum on the west coast of Scotland has a large Manx shearwater colony and one of the island's summits has the Norse name Trollaval, while other shearwater islands in the Faeroes have troll-related names too.

The fact that shearwaters are most active on the darkest nights adds to the ghostly impression. Graceful in the air, a shearwater is a slow, waddling

Above: Over the centuries, many ships have come to grief on the rocks around Skokholm, including the schooner *Alice Williams*, which sank in the island's Wreck Bay in 1928.

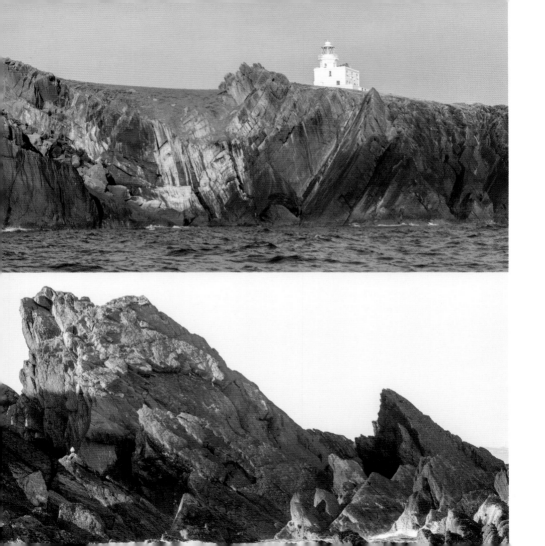

target once it is on the ground and is vulnerable to predators. On moonlit nights shearwaters run the risk of being ambushed by gulls, so the colony is most active when clouds hide the moon.

It adds to the oddness of the experience for human visitors – you hear the rush of air over wings in the darkness, but do not see the fast-flying birds. A torch helps, but it can increase the chances of a collision. Shearwaters often fly towards a light.

Activity on Skokholm is close to a 24-hour business. Soon after the shearwaters have fallen silent, the day begins.

Just about a mile long and half a mile wide, Skokholm is smaller than its better-known neighbour, Skomer. As the ferry heads out past Skomer and across the notoriously choppy Jack Sound, the visitor has a chance to compare the neighbours; where Skomer has shape, Skokholm is a plateau.

A slab of sandstone, Skokholm is close to flat. Much of its surface is a moonscape where close-cropped turf is more sea thrift than it is grass and a misplaced boot can collapse a burrow on its occupant (either a rabbit or a fat, fluffy shearwater chick).

Left: Skokholm Island is made up entirely of mudstones and sandstones.

Grim remnants pay testament to the very real hazards that face visiting shearwaters. Here and there on the ground are desiccated scraps of bird, a wing or perhaps a foot.

Like Skomer, Skokholm has puffins – fewer of them, but plenty; sitting in the tiny hide at Crab Bay you are often surrounded by puffins. Other seabirds nest around the island too, including guillemots and razorbills, and it makes for good hunting for the island's resident peregrine falcons.

When the day ends, rabbits come out of their burrows and sit in the evening sun. On a good night they are silhouetted against the flare of the last sunlight across the western horizon.

Shearwaters aren't the only nocturnal bird visitors. Storm petrels come at night too, visiting nests in crevices between rocks on the sea cliffs.

The island's natural history is among the most closely-studied in the British Isles, because Skokholm became Britain's first Bird Observatory in 1933. It was the brainchild of a young naturalist called Ronald Lockley, who chose island life.

The observatory ceased to exist in the 1970s, but was reborn in recent years after the island was purchased by the Wildlife Trust of South & West Wales. It's now operated as one of a network of

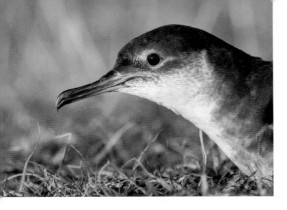

Lockley found that he could earn better money from writing books and articles.

The Lockleys made their home in the island's farmstead, a well-worn cluster of buildings hunched into a fold of land. It's now a base for the small team who run the island.

Lockley could find little about shearwaters in his bird books and even today the bird remains something of a mystery. Even counting shearwaters is a challenge. The most reliable survey method involves playing taped calls at the mouth of burrows and listening for a response.

Not all birds will answer on demand, but a count of those that do can give an indication of colony size. Today it's thought that the world's population is around 400,000 pairs. Of the UK population, about half breed on the Pembrokeshire islands – 120,000 pairs on Skomer and 45,000 on Skokholm.

Our human world and the Manx shearwater's marine one only briefly overlap. The shearwater spends most of its life at sea returning to land only to breed. When they leave the Pembrokeshire coast at the end of the

observatories around Britain and Ireland.

Ronald Lockley was born and brought up in the Cardiff area and was running a chicken farm when he first visited Skokholm with a companion. In an introduction to *Letters from Skokholm*, a collection of her father's correspondence, his daughter Ann writes of that visit: "Both fell immediately in love with what they saw. From that moment my father could not get the island out of his mind."

Lockley called Skokholm 'Dream Island'. But he was a doer as well a dreamer, so he approached the island's then owner and negotiated a lease. Soon after, the newly-married Mr and Mrs Lockley set up home on their island.

Their adventures are described in a series of books that became bestsellers during the 1930s. The original plan of rabbit breeding was soon abandoned, as

Right: With feet that are set close to its tail, a shearwater finds moving on land challenging.

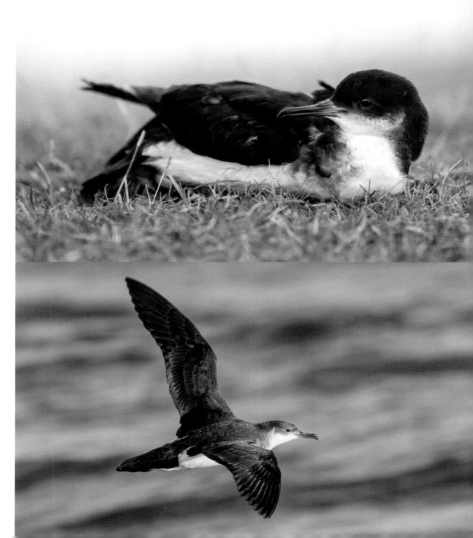

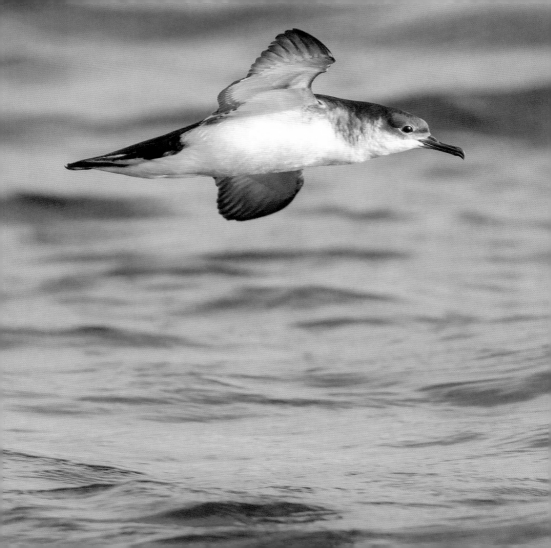

summer they cross the Atlantic, escaping the northern winter for milder months on the coasts of Brazil and Argentina – one of the biggest puzzles is how recently-fledged youngsters make that journey.

Shearwaters return to Pembrokeshire's islands in early spring. Mothers lay their single egg in late May and their chicks hatch in mid-July. It's then around 70 days before the youngsters are ready to fly.

You would expect parents to lead the way, but they head south ahead of their offspring. The chicks are left to survive alone on their fat reserves until they are ready to leave too.

Ronald Lockley recorded the process in his book *Dream Island*. It was nearly two weeks before the abandoned youngsters he was watching were ready to go beyond the safety of their underground homes.

"Wherever we walked on the Island at night... these hungry little figures could be seen sitting at the mouths of the rabbit burrows, waiting perhaps for the parents that would never come again," he wrote.

When the time is right, the young shearwaters leave in the dark and head straight to the sea. At the clifftops they half-fly, half-tumble over the cliffs into the water below.

On land they are hapless – many are taken by predators – but on the water they are in their element. Lockley observed: "One imagines that they have little difficulty in quickly obtaining a meal of sprats or fry and thus breaking their long fast."

When the time is right, the young shearwaters leave in the dark and head straight to the sea.

Of every 10 chicks that hatch on Skokholm, nine leave the island successfully, an excellent statistic. How they then make the huge journey to South America is a mystery, but they do.

A year later, only one in three of those youngsters survive, but that's not an unusual casualty rate for wild birds. Many of those that do survive that first year then go on to live very long lives; ringing studies have shown that a lucky few reach their 50s.

And throughout that long life they return to the same island, even the same burrow, time and again. It's one of the wonders of wild Wales.

Left: Shearwaters are at ease over ocean waves, often cruising so close to the water that their wings clip wave tops.

Visit

Overnight access to Skokholm Island (grid ref. SM738051) can be booked as three or four-night breaks with the Wildlife Trust of South & West Wales (www.welshwildlife.org), but places are snapped up well in advance as accommodation on the island is limited.

Also

On a warm evening, take a torch and go rockpooling at sunset. Lots of the animals that live in rockpools are more active after dark, so there should be more to see. Just about any beach will do, but good locations include: Dunraven Bay (SS 884 730), Southerndown, near Bridgend;

Broughton Bay
(SS 420 934), near Llangennith, Gower,
and Cable Bay (SH331 705), near
Llanfaelog, Anglesey.

Above: The island's weather-worn
buildings include recently refurbished
guest accommodation.

September

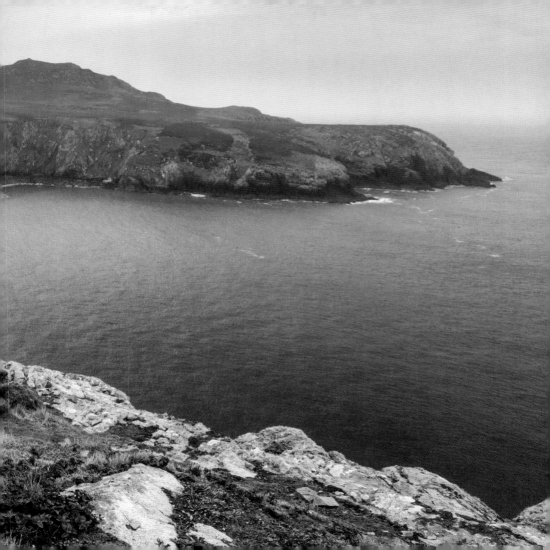

9. Maternity unit
Ramsey Island, Pembrokeshire

Just 2.5 miles (4km) west of St Davids (as the chough flies), Ramsey is separated from the mainland by the narrow Ramsey Sound.

From the lifeboat station at St Justinian, Ramsey Island, Ynys Dewi, seems temptingly close. On a calm day, the Sound, a mile or so across, looks almost narrow enough to swim.

In fact, the gap between island and mainland is one of the most treacherous stretches of water around the coast of Wales. As the tides move, water forces through the channel to roar over a string of shark-tooth rocks called The Bitches.

At times the current accelerates to more than 15 knots, pushing up huge

Right: Seal pups weigh 14kg at birth, but fatten up rapidly on their mothers' rich milk.

standing waves that kayakers queue up to ride. Our ferry journey across is, thankfully, no more than choppy.

Of Pembrokeshire's islands, Ramsey is, arguably, the most rugged and dramatic. It is a National Nature Reserve and has been owned by the RSPB since the early 1990s.

The antiquarian Richard Fenton wrote about the island in *A Historical Tour Through Pembrokeshire*, which was published in 1811. He clearly saw Ramsey as first among the Pembrokeshire islands, although that may reflect local bias – he was born in St Davids.

He said: "This island is all high ground, but at the two extremities of it rise two mountains of great height, giving it a very grand and romantic appearance; whereas Caldey and the other islands off Milford are level and tame."

To call Ramsey's twin hills mountains is a bit of an over-statement. The taller

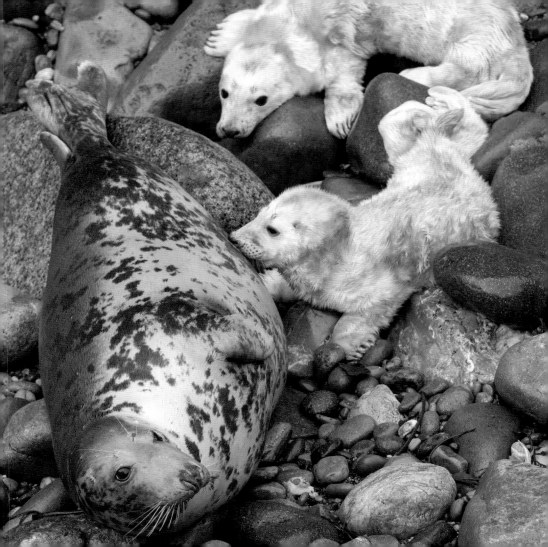

of the two, Carn Llundain, reaches 136m (446ft), while the other, Carn Ysgubor, is 101m (331ft) high.

But the view from either summit is hard to beat. To the west, beyond the string of islets called the Bishop and the Clerks, the hills of Ireland are just about visible, while to the south and east it seems as though all of Pembrokeshire is there to see.

In the warmth of the September sun it feels as though summer will last for weeks, but autumn is just around the corner. The heather that covers much of the island has lost its colour, bracken is yellowing and the occasional swallow crosses the island, heading south and flying fast and low.

Ramsey is well worth a visit at any time of year, but one of the most interesting months is September. It's then that the island's grey seals return to what is the largest breeding colony in southern Britain.

Pups are born all year round, but most cows give birth in autumn and around 600 pups a year are born around Ramsey. Many start life on the beach at Aber Mawr, a huge bite out of the island's western coast.

From the lower slopes of Carn Ysgubor the view across the beach is striking – it's so full of life. At first glance the pups are easy to spot, their off-white coats a stark contrast to the grey of the beach.

Their mothers are hard to make out, as their dappled grey colouring means that they are well camouflaged among pebbles and sand. Often ravens are there among the cows and pups too, squabbling over scraps of after-birth.

Beyond the surf, big bull seals wait for females. Some sit up straight in the water, watching what's happening on the beach, while others are patrolling shadows just below the surface.

The beach is a noisy place too. When the wind drops, the sounds of the seals can be clearly heard from the clifftops; the eerie cries of the pups and the growls and grunts of the adults.

Grey seals spend most of their lives at sea, but that changes during the breeding season. During their stay at the breeding colony both males and females fast, living on their blubber – the thick fat layer that serves as an energy store and insulates against the cold.

Grey seals spend most of their lives at sea, but that changes during the breeding season.

Newborn pups are born with creamy-white coats, but within a couple of weeks grey hairs push through and the white ones are shed. The youngsters suckle

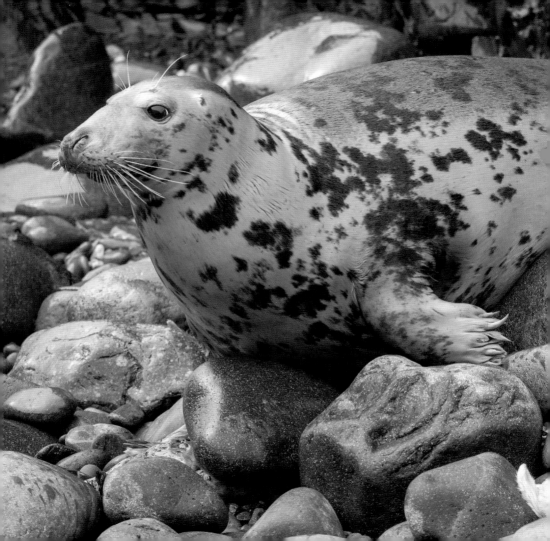

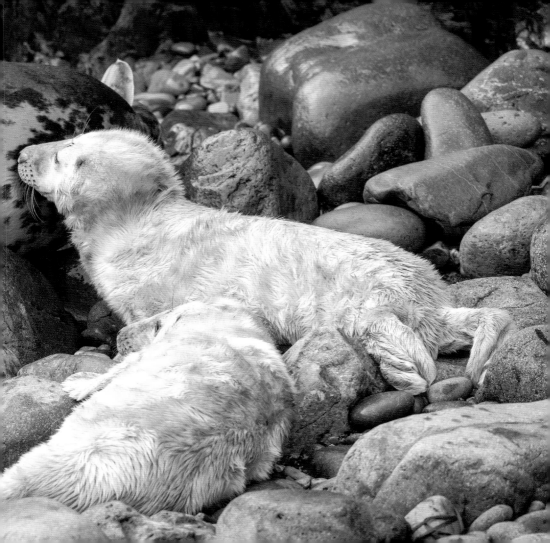

milk that is very rich in fat and protein; it's so nutritious that their weight trebles in their first three weeks of life.

At birth pups weigh around 14kg (31lbs) and they gain weight at a rate of around 2kg (4.4lbs) a day. The cost of feeding a pup takes its toll on a cow and over the same three weeks she will lose around a third of her weight.

Usually Ramsey's cows spend around 20 days at their breeding site, often returning to the same spot year after year. During those 20 days they bear and suckle a pup before coming into season around the end of lactation.

They mate soon after. A few dominant bulls monopolise the cows in the territory they make their own.

When the females have mated they return to the sea, leaving their offspring to fend for themselves. They face quite a challenge, learning to fend for themselves just when the storms of autumn are rolling in from the Atlantic.

The young seals born on Pembrokeshire's islands often travel huge distances in their first year. In the 1950s the naturalist Ronald Lockley tagged young seals from Ramsey and Skomer in the hope that their movements could be tracked. Some of his Ramsey seals were later recaptured and had wandered as far afield as Cornwall, Brittany and the west of Ireland. In one case, a female born on Ramsey travelled 250 miles to Finistère in just 16 days.

Away from the beaches and caves there is lots more to see on Ramsey in September. All paths converge on the farmhouse, which is now home to the RSPB's reserve team.

Ramsey has been home to some sort of community for close to 2,000 years and probably longer. Even today poor weather can trap its inhabitants on their island for days, so in the past they must have been particularly self-sufficient.

Fenton says the first of the island's two saints was Devanus, or Devynog, who arrived in Britain in 186 AD and later retired to Ramsey. His chapel is said to have stood close to what is now the farmhouse garden.

Saint Justinian's chapel stood to the north of the harbour, close to the cliff edge. He was a Breton hermit who lived on Ramsey in the 6th Century and became both confessor to Saint David and abbot.

Justinian seems to have been a difficult man. He's said to have become unhappy with the attitude of the abbey's monks and returned to live on Ramsey, only to be murdered by his followers when they

Right: A pup has to mature quickly. After just three weeks, mothers leave their offspring, ready to mate again.

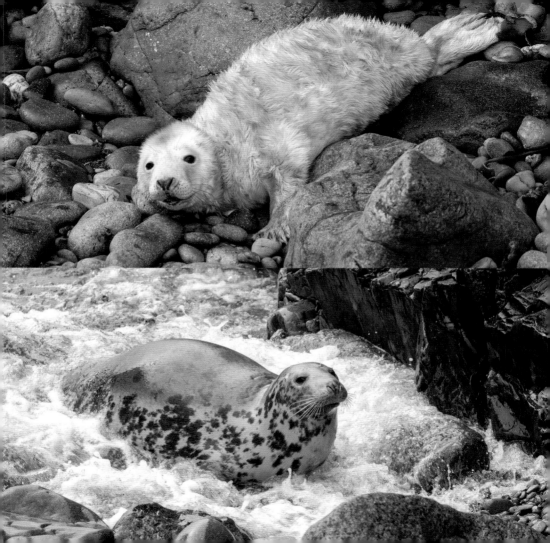

revolted against his strict regime.

In one story it's said that Ramsey had been joined to the mainland in Justinian's time, but that he prayed that the narrow neck of land be cut so that he would be left in peace. His prayer was answered and all that remained of the land bridge are the rocks that can be seen in the Sound at low tide.

In more recent times Ramsey was home to farming tenants of the Bishop of St Davids. A survey of the bishop's property from 1326 speaks of a regular ferry that would carry 'beasts' to the mainland. Rabbits were a staple 'crop' for islanders, with hundreds being sent across the Sound each year.

When Richard Fenton paid his visit he commented on how few rabbits he found. He does say that they were previously "so numerous", which suggests that he had visited Ramsey before.

He thought that the cause of the decline in rabbit numbers was that they had been over-powered by rats, which indicates that Ramsey had a rat problem at the time. He adds: "There are but few puffins to what I recollect."

How and when rats arrived on Ramsey is open to question. A large rat population can have a serious impact on seabird colonies because rats will take eggs and chicks from any nest they can reach.

The first rats may have been carried across the Sound with supplies, but there is another possibility – shipwreck. Fenton describes one of the many shipwrecks that have happened on Ramsey and its islets, which he says occurred 30 years before he was writing.

As the Swedish vessel sank, its crew managed to get to one of the Bishops. But, having saved themselves from drowning, the Swedes seemed doomed: "Without covering, food, or any hope of escape, they considered their fate as inevitable".

Luckily, a woman living in a house on the mainland was in the habit of looking out to sea through a telescope, Fenton reports. She raised the alarm and the crew were saved.

However Ramsey got its rats, they have made their presence felt. Puffins abandoned the island some time over the last couple of centuries, while the Manx shearwater population has been severely restricted.

Things have started to change since a drive to eradicate rats in 1999 and 2000. In 1999, 897 Manx shearwater pairs nested in burrows on Ramsey, whereas in 2012 the figure was more than 3800.

Right: Other than the resident sheep and rabbits, Ramsey is a great place to see the rare chough.

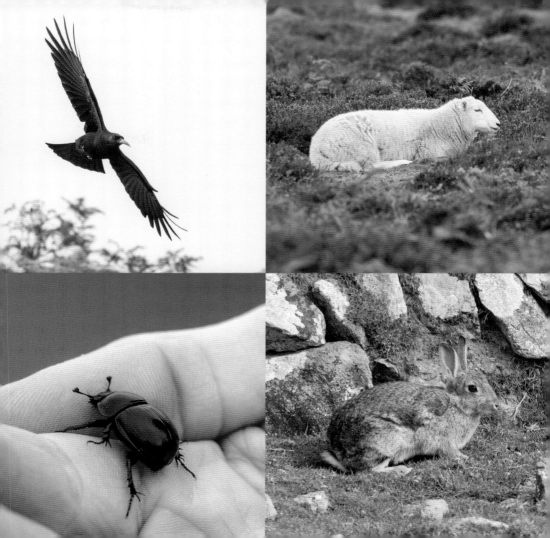

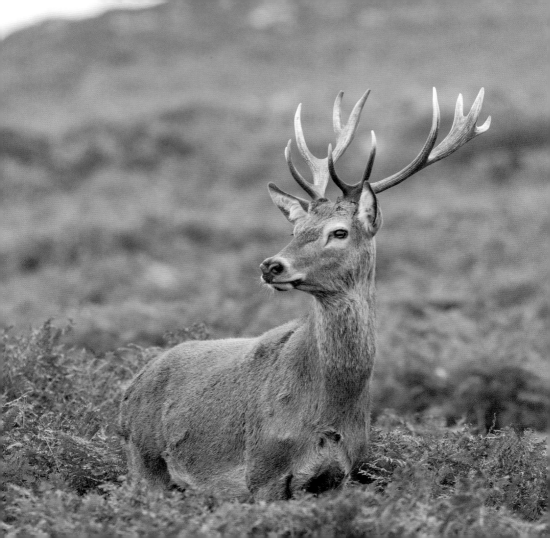

It's thought that the new arrivals are shearwaters that have moved from Skomer or Skokholm, where competition for burrows is intense. Another burrow-nesting seabird, the storm petrel, has also returned to the island and there are hopes that in time puffins will too.

In September, most of the island's seabirds have moved on, but there is plenty for birdwatchers to see. Ramsey's well-grazed turf makes it perfect for choughs and up to eight pairs breed in the island's sea caves.

In early autumn, flocks of choughs can be seen all around the island, probing the soil with their curved, bubblegum-pink bills. But the island's most surprising residents have to be its small herd of resident red deer.

During the 1970s red deer were farmed on Ramsey and when the farming operation came to an end all but a few of the animals were taken off the island. But a few were overlooked and their descendants now have the freedom of their island.

There are only around a dozen deer, but that herd includes a trio of big males.

Left: One of Ramsey's surprises is its herd of red deer. The island is one of the few places in Wales where they can be seen.

Their presence on Ramsey means that in September a visitor can enjoy watching two of Britain's most charismatic mammals on the same day – red deer and grey seal.

Visit
Weather permitting, boats cross from St Justinian to Ramsey (grid ref. SM706237) every day at 10am and noon, with a return trip at 4pm. The service is operated by Thousand Island Expeditions, of St Davids, tel: 01437 721686.

Also
Grey seal pups can be seen in smaller numbers at lots of other locations around the Welsh coast. Around 150 pups are born each year around Ramsey's neighbour, Skomer Island (tel. 01239 621600, welshwildlife.org), and there are colonies around Bardsey Island and the St Tudwals Islands, off the Llŷn (boat trips by Shearwater Cruises (tel. 01758 612251, shearwatercruises.com).

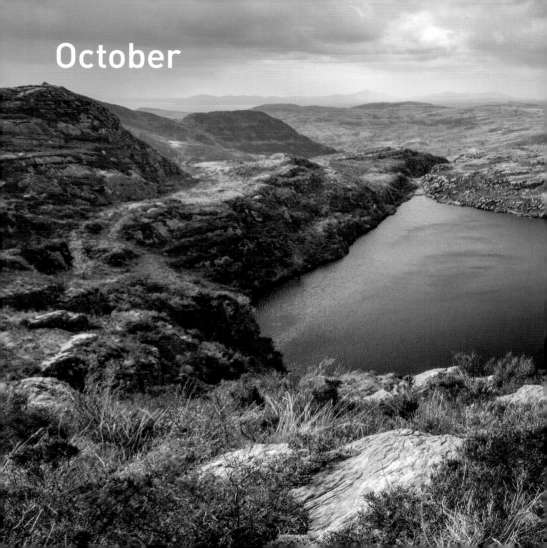

October

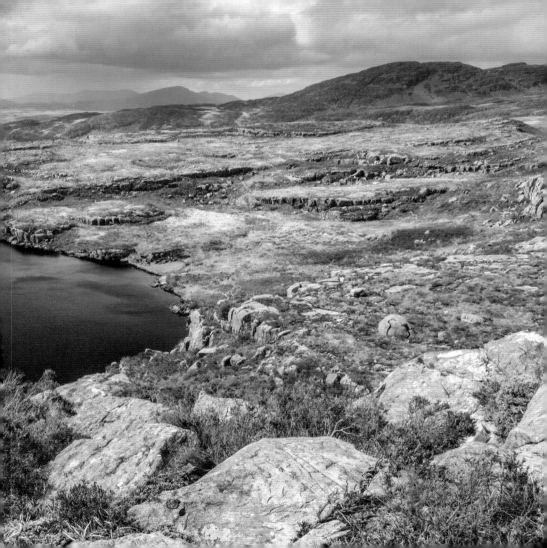

10. Mountains and rainforest
The Rhinogydd, Gwynedd

The mountains of the Rhinogydd are north of Dolgellau. They can be explored on foot from both the A470 and the A496.

The late 18th century saw a fashion for travel writing. For a time the Welsh travelogue was in vogue, colourful descriptions of the experiences of (mostly English) gentleman travellers 'discovering' Wales.

One of the most successful was a series by a Flintshire naturalist and antiquarian, Thomas Pennant. One episode from his travels that Pennant describes in *Tours in Wales* saw him venture into the mountains above Harlech to visit a farmer called Evan Llwyd, who lived at Cwm Bychan.

Right: Walking high above Coed Crafnant is a real experience into the wilderness, stunning views and terrain.

Today a narrow tarmac-topped road takes you to Cwm Bychan, one of very few that reach into the Rhinogydd. At its end there's a small campsite, but otherwise Cwm Bychan must be much the same as it was when Pennant called on Llwyd, writing: "The naked mountains envelope his vale and lake, like an immense theatre."

The visitor was, he reports, received by a host who was hospitable "in the style of an antient Briton"(sic). Pennant goes on: "He welcomed us with ale and potent beer, to wash down the Coch yr Wden, or hung goat, and the cheese."

Pennant did much better than that much earlier traveller, Giraldus Cambrensis. The 12th-century cleric said the Rhinogydd was the "rudest and roughest district of all Wales", but chose not to put that assessment to the test – he went no closer than the coast road.

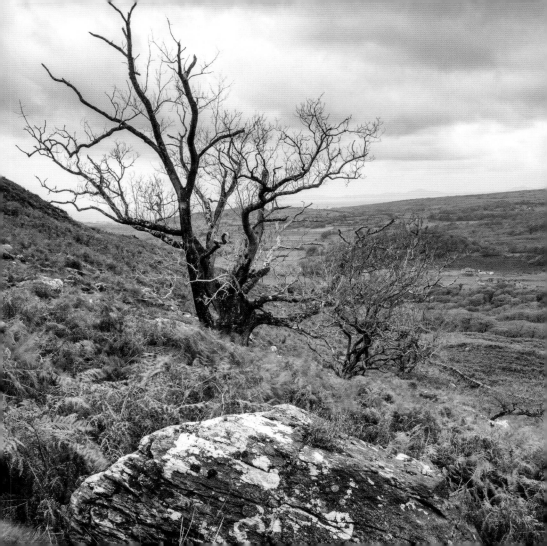

It's certainly one of the most rugged terrains in Wales, a wild, open landscape that is a joy to explore. From Cwm Bychan a path heads up and out of the oakwoods and up to a pass in the mountain range on a paved section that is known as the Roman Steps.

The path probably existed long before Rome's legions came to Wales, but the paved steps are medieval. Whenever the path was first walked, it is a reassuringly easy route to follow in hills that are notoriously easy to get lost in.

The Rhinogydd is a landscape that seems more rock than not. Even in October, when you are sheltered from the wind, and in the heat of the afternoon sun, the range has a feel of somewhere other than Wales. Greece maybe, or perhaps Iceland.

Huge pillows of rough, grey rock litter the upper slopes among low-growing heather and bilberry. Here and there is a stunted rowan, or a mountain ash, with slim branches weighted down by clusters of orange berries.

It all looks parched and dry. But among the slabs and boulders shallow pools are thick with vivid green sphagnum moss.

On the way up we stop every five minutes or so to scan the slopes and crags for goats. It's surprising how many goat-shaped boulders there can be on one mountain.

But in time we find what we're looking for – three billys grazing in the shelter of a bowl-shaped cwm. The trio watch us; they're wary but not spooked, and after a moment all three return to their grazing.

When we move a little closer to get within camera-range, their heads lift once again and, without haste, they pick their way away from us between rocks. When they have gone there's time to take in their mountain 'kingdom'.

The Rhinogydd is unlike anywhere else in Snowdonia – and for that matter, in the rest of Wales or England. It's also one of the less well-known parts of the National Park, a wild stretch of uplands where you can explore without meeting other walkers even during high summer.

If you do know the range it's probably by another name – the Rhinogs. From north to south the range is around 20km long and the tallest peaks are in the southern half.

It takes its name from two of those summits, Rhinog Fawr (720m) and Rhinog Fach (712m). The Welsh plural form is anglicised by adding an 's' to make Rhinogs.

Right: The range's wild goats are tough survivors, weathering the elements in a very hostile environment.

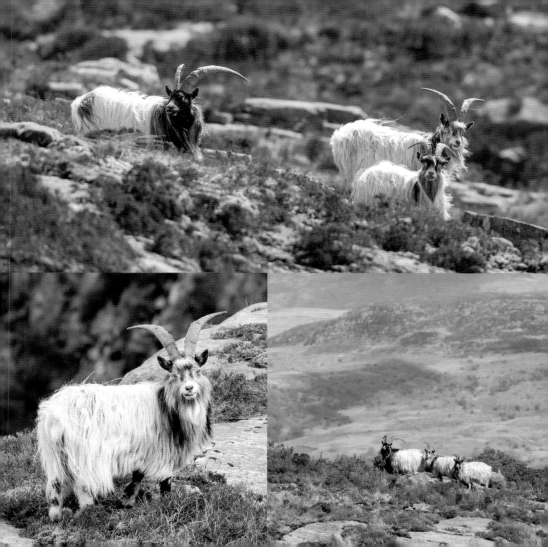

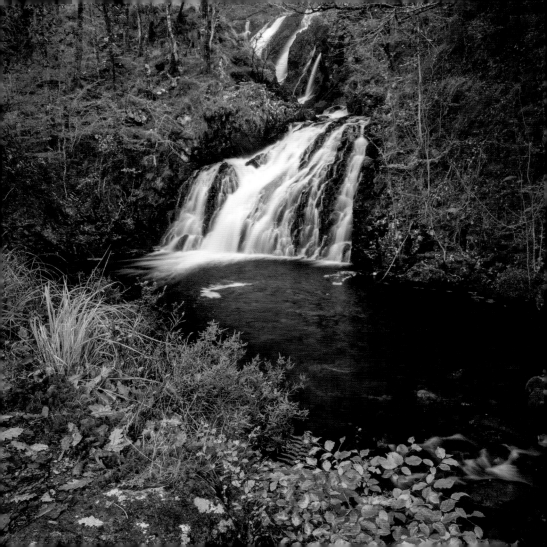

The highest peak in the range is actually not either Rhinog. At 756m, Y Llethr beats Rhinog Fawr by 36m.

Most of the other locations featured in this book are on a more human scale than this block of mountains. The central core around Rhinog Fawr is about as protected as a British landscape can be – it's in a National Park and is a National Nature Reserve (NNR), a European Special Area of Conservation (SAC) and a Site of Special Scientific Interest (SSSI).

The SSSI has the widest reach. It takes in an area just a little short of 3,300ha (8,150 acres).

What gives the Rhingoydd its very special character is its geology. Many of Snowdonia's rocks are ancient, but its oldest physical feature is a huge anticline, or fold, that's called the Harlech Dome. The largest area of Cambrian rocks in Wales, the dome stretches as far as Snowdon to the north and Cadair Idris to the south.

The Rhinogydd is at its centre, where original mudstone and sandstone were later altered by volcanic activity. The heat transformed them into the tough slates

Left: Rhaeadr Ddu (Black Waterfalls) are at the top of the Coed Ganllwyd walk, a very rewarding view after the ascent through the woodland.

and grits of today.

It is around 4.3 miles (7km) as the crow flies from the summit of Y Llethr to Aber Eden, where the Eden joins the Mawddach. Flying dead level, that crow would be around 700m above ground level over the Mawddach.

Along the way it would overfly a series of contrasting vegetation zones, from barren mountain top all the way down to incredibly lush valley woods, which can be seen at their best at the Dolmelynllyn Estate.

Annual rainfall totals in Snowdonia are high, so high that around the Rhinogydd the oakwoods that clothe the range's lower slopes rate as temperate rainforest. That word 'rainforest' conjures up images of tropical jungle, but the world's temperate zones have rainforests too.

Like the woodland at Dolmelynllyn, these cold-climate rainforests are often close to the coast; they occur in parts of Chile, southern Australia, New Zealand and Spain and Portugal. Here in Britain, the oakwoods of western Scotland and parts of north-west and south-west England qualify, as do those of southern Snowdonia.

On the ground what you see is incredible variety. The sheer range of plant species is enough to make a

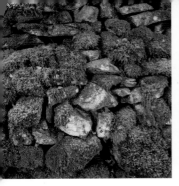

botanist's head spin.

The combination of relatively mild winters and moisture-laden air that is rarely dry is particularly good for ferns, mosses, liverworts and lichens. In all, 174 species of mosses and liverworts have been found at Coed Ganllwyd, as well as 200 different lichens and nine ferns.

For woodland lichens alone, Dolmelynllyn rates as one of the finest sites south of the Scottish highlands. Of course, lists of species do not mean much to the non-botanist, but the sheer abundance and variety of plants at Coed Ganllwyd is breathtaking.

The rainforest experience is at its most intense in the rocky gorge of the Afon Gamlan. Whitewater thunders over the series of waterfalls that make up Rhaedr Ddu (Black Falls) and the river's spray fills the air.

Even when it's not raining, it's near impossible to walk the gorge path without getting wet. The saturated air means that mosses and filmy ferns are at their most luxuriant and every surface is carpeted in green.

Moss grows so thickly on the boulders that if you take a moment to rest on a rock your seat is cushion-soft; sink your fingers into the moss and it's knuckle-deep.

In October the path is littered with gold-edged, curling oak leaves, although most of the tree canopy overhead is still in place. During the summer the woods are alive with breeding birds, which nest in holes in tree trunks and boughs.

Many, like the pied flycatcher and

Above: Thanks to the rainforest climate at Coed Ganllwyd, there's a fantastic array of mosses and lichens on display; including the rare lungwort.

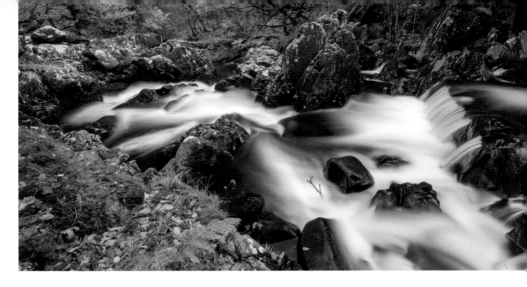

willow warbler, are migrant songbirds that come to Wales for the summer. By October they are long gone and the woods are quieter, although you are likely to hear the harsh screech of jays.

In good years the acorn crop creates a food glut.

In autumn, jays are busy collecting acorns, which they bury to provide a store of calories to return to in the tough months of winter. A single jay will work

for up to 10 hours a day, storing away as many as 5,000 acorns.

As you climb further out of the valley you enter a more open landscape, where bracken is gaining autumn's rust brown. One lichen that is worth looking out for is lungwort (Lobaria pulmonaria), which likes more sunlight than is to be had lower down the hillside and can be seen on mature oaks, ashes and sycamores.

The vivid green scales were once used as a treatment for lung illnesses because it was thought to look like the lobes of a lung; under the old rule of signatures, herbs were selected for medicinal use if

Above: Rhaeadr Ddu through Coed Ganllwyd. A relatively short walk with lots of interest through the autumn months.

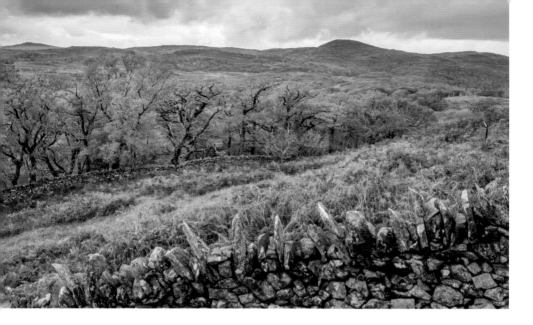

they were thought to look like parts of the human body.

The open landscape on the mountains' lower slopes is ffridd, the land between enclosed fields and open hill that is peculiarly Welsh. On the eastern flank of the Rhinogydd it is a mix of woodland, bog, grassland, heath and bracke,n where grazing animals roam freely.

In winter the Rhinogydd goats drop

Above: Close to Carreg Fawr above Coed Crafnant.

down out of the crags to graze and browse these lower slopes, but for most of their year they prefer to be at a higher altitude. The range's heath is one of the largest in Wales, a mix of heathers, bilberry and gorse.

In summer, wheatear and ring ouzel breed in the heathland, which is also home to small populations of black and red grouse. It's a habitat that seems to suit goats.

Feral herds roam in a number of areas within Snowdonia, but the Rhinogydd

group – which numbers around 800 animals – is one of the most successful. A paper written in 1968 pulled together field observations of Snowdonia's goat population and its authors noted: "There is little doubt that feral goats have been present on the Welsh mountains for a very long time, possibly ever since goats may have escaped from the domestic herds of the Neolithic settlers in the area."

They certainly seem to be at home, with shaggy coats colour-coded for camouflage in the rocky landscape. If you do spot them they are often in same-sex groups; females are usually lighter in colour and smaller, and also have thinner, shorter horns.

As they mature, the billy goats grow impressive scimitar-shaped horns. A three-year-old male's horns will be around 40cm long, but if he survives to be a 10-year-old they will be double that length.

Through much of the year the animals range in groups of less than 10, but larger groups form as the autumn rut approaches. Only a few of the older, more-dominant billys get to mate and competition for females is intense.

As rivals measure one another up the two bleat and snort. Finally, they fight, crashing together head to head.

After the initial impact, the opponents will stay locked together for up to an hour until one of the duellists yields. The winners will earn the right to father kids, which will be born in early spring.

They may not be popular with farmers, whose walls they damage, or with conservation professionals, whose rare plants they nibble. But it's hard not to admire them, they're tough and rugged – just like their hills.

Visit

To walk the Roman Steps, start from the farm at Cwm Bychan (grid ref. SH645314), which is east of Harlech. To visit Rhaedr Ddu and explore the eastern slopes of the range, head to the National Trust's Dolmelynllyn Estate (nationaltrust.org.uk/south-snowdonia) at Ganllwyd, on the A470 north of Dolgellau.

Also

As the days shorten, the green chlorophyll pigment in tree leaves fades and the colours of other substances catch the light. Carotenoids give autumn trees their red and orange colouring, while flavenoids are yellow. Beech trees look particularly good as they undergo the colour change; Wales' largest beech wood is Cardiff Beech Woods at Taff's Well, just north of Cardiff (ST115833, cardiff.gov.uk).

November

11. **Numbers game**
Newport Wetlands, Uskmouth, Gwent

The Newport Wetlands reserve visitor centre is 2.5 miles (4km) south of Newport at Uskmouth.

During the winter, the landscape of the Severn Estuary has a grim, big-skied beauty. In the pasture that stretches away towards the shoreline, sheep graze among pools of water that are spiked with rushes and, here and there, lapwings roost or preen.

Between the fields, drainage ditches that are ruler-straight are full of tall reeds that move in the wind. Away to the east the Severn Bridge is a landmark, while to the west are huge industrial buildings and a forest of pylons and

Right: Nature and industry share space at the mouth of the Usk.

chimneys on the outskirts of Newport.

Low and flat behind its sea wall, the coastal strip feels somehow un-Welsh – much more like the Somerset Levels or the fens of eastern England. A National Nature Reserve, Newport Wetlands is a fascinating place to explore, and what makes it particularly interesting is that it is a wholly man-made countryside.

If there were no sea wall, the Severn would reclaim many miles of what is now farmland. Once known as the Monmouthshire Moors, the Gwent Levels extend for about 18 miles (29km) on either side of the mouth of the Usk.

To the west of Newport is the Wentloog Level, while to the east is the Caldicot Level. In prehistoric times they were mostly tidal marshes, with a few islands here and there.

The first attempts to drain the marshland are thought to have taken place during the Roman occupation, when

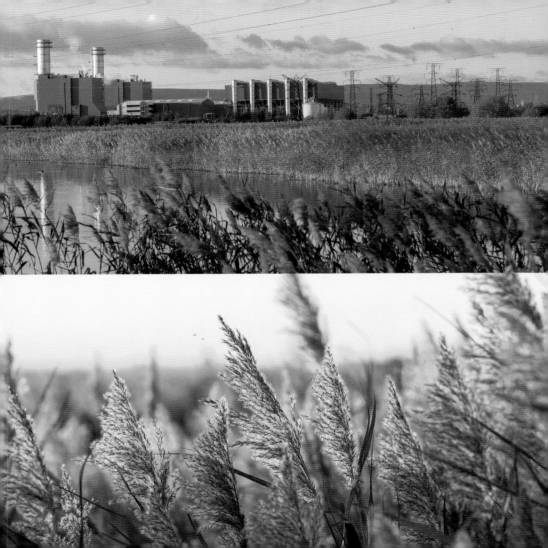

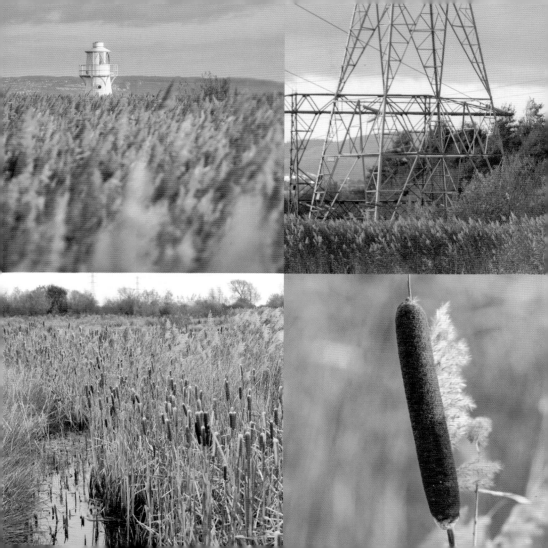

a sea wall was constructed and drainage ditches were dug; Roman cavalry horses from the military centre at Caerleon may have grazed on the newly-drained land.

In Norman times, a priory was founded at the village of Goldcliff. Its Benedictine monks extended their farmland with more drainage and sea defences.

A landmark at the east end of the reserve is a stubby lighthouse, which stands on the sea wall.

Even so, levels communities were still vulnerable to the sea. Jan Morris describes the great flood of January 1606, when the sea "came suddenly storming over the flatlands".

The water moved faster than a running greyhound, one contemporary report says, and whole villages were swept.

A plaque in Goldcliff's St Mary Magdalene Church remembers the flood, saying: "In this parish heare was lost 5000 and od pownds besides XXII (21) people was in this parish drown."

A landmark at the east end of the

Left: Newport wetlands is a fabulous habitat with vast reed beds and waterways hosting a wealth of wildlife.

reserve is a stubby lighthouse, which stands on the sea wall. On one side it overlooks saltmarsh and, when the tide is out, expanses of mudflat, while on the other there are reedbeds and open water.

On a chilly afternoon, a few birdwatchers, bundled in thick coats, hats and gloves, are gathering by the lighthouse to wait for the 'show'. In early winter, around 50,000 starlings pass each night, roosting in the reeds near to the lighthouse, and their arrival as dusk falls is a spectacle that it's well worth braving the cold to see.

Newport Wetlands is a relatively-recent creation. It has been developed since 2000 to create habitat for birds as payback for feeding grounds lost as a result of the building of the Cardiff Bay Barrage.

The reserve is large, 437 hectares (1,080 acres) in all and 2.5 miles (4km) from one end to the other. Close to the Usk, areas that had been used for dumping power station ash have been converted into a reed swamp, one of the biggest areas of reeds in Wales. Further east, large areas of low-lying grassland are important for breeding birds, and, near Goldcliff, salt-water lagoons have been created that attract flocks of lapwing.

As the reserve has matured, birds have moved in – more than 200 species

have been recorded. During the winter, wildfowl like wigeon, shoveler and teal gather on the open water, while bitterns and water rails make use of the reedbeds. In summer breeding birds include lapwing, redshank and even avocet.

But at 4.15pm on a grey November day, the main attraction is the coming of those starlings. The starling is, of course, one of our most familiar garden birds and one that, on the whole, is taken for granted.

Sociable, quarrelsome, and rarely quiet, their vocalisations include an incredible mix of trills, warbles, rattles and clicks. Given their enthusiasm for communication, it comes as no surprise that they are closely related to the mynah bird.

They are common in Wales, and the rest of Britain too. The UK breeding population

Above: Along the sea front, look out for shore birds like this snipe.

is reckoned to be around 800,000 pairs, although the starling population has been in steady decline for 30 or 40 years.

Flocking is common in the world of birds, but not often on this scale. Starlings get together in massive flocks during the winter, to roost together during long, cold nights. Why they do it is open to question; it's possibly that they feel safer from predators when they are part of a large group or that they benefit from pooling body heat.

Another benefit they gain from communal living is that flock members get more to eat. By following birds that know where to find food, youngsters are less likely to go hungry themselves.

Lots of starlings breed in Wales, nesting under eaves or in suitable holes in trees and the offspring of these Welsh birds usually don't travel that far home. But from late summer onwards the number of starlings in Wales grows sharply, as birds from the Continent fly in to spend the winter in Britain. The winter visitors come from Scandinavia, the Baltic states, Germany, Poland, and even Russia.

It means that winter roosts, like the one at Newport and others around Wales (for example, at Aberystwyth Pier and at Plumstone Mountain in Pembrokeshire) are big. In mid-winter, tens of thousands of birds often get together each night.

Waiting by the lighthouse it's difficult to know which way to look. During a November day, starlings are busy foraging for food in the countryside around their roost, travelling up to 50 miles from 'home' during daylight hours.

They like to feed on grassland, probing the ground for grubs, so the levels are a perfect opportunity. By late afternoon birds get together at gathering points not far from the roost, often a farm or somewhere else where food is relatively easy to find. There they get ready for the night ahead by feeding, preening their feathers and bathing.

Small flocks then begin to head towards the roost, joining up with others as they go. What happens when the birds all arrive over the roost depends largely on the weather. On wet or windy nights there's no display flight, the birds just hunker down for the night ahead. But when the weather is fine and there is little wind, the 'show' can be exceptional.

At the lighthouse, the first of the starlings finally turn up, a long, sinuous snake of them framed between pylons and a tall, brick chimney.

In flight they are silent, but when they settle on one of the pylons there's an

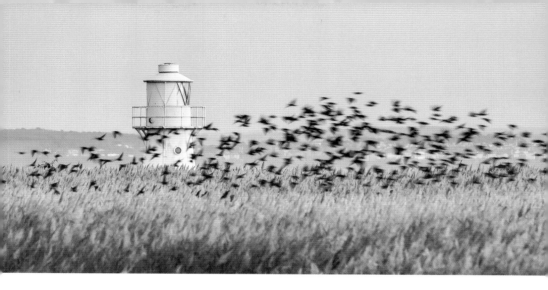

explosion of noise as thousands of birds 'talk' at once. In a moment they're off again, swooping away to the east and are soon lost to sight in the failing light.

As time goes on, smaller flocks are arriving and becoming part of the main flock, so when it reappears it has grown even larger. The horizon over Newport is washed pink, but overhead the sky is

Above: Before the main spectacle, smaller groups of starlings will gather amongst the reeds before taking flight and joining the larger flock.

Prussian blue and as they pass by each starling is a silhouette, an outline in perfect sync with its neighbours.

What follows is known as a starling murmuration and is difficult to describe. It amounts to a 15-minute aerial ballet, as the shape-shifting mass of birds moves around the darkening sky above the reeds.

One minute the swirling, liquid mass is high above the pylon tops, the next it's skimming by just above our heads. A murmuration is an unpredictable event. Conditions can be seen just right, but the

birds stay away from the party.

When the 'show' does happen, it's sometimes sparked by the presence of a predator, like a peregrine falcon. If a falcon strikes it usually ambushes a lone straggler, so packing closely together offers some protection.

From the ground the mass of birds moves like an intelligent cloud. How they manage to change direction and speed in unison has puzzled scientists, but in recent years high-speed filming has allowed the phenomenon to be studied closely.

What happens is that each bird reacts to the actions of its closest seven neighbours – if one bird changes direction, or speed, the rest do too. That degree of synchronisation is replicated throughout the entire flock to create an incredible overall impression for the human observer.

In the end there's a sense that the whole flock is waiting for a single brave soul to take a lead. When birds do break away they do it as quickly as they can, dropping from the sky into the shelter of the roost – whether that's a reedbed, a copse of trees or the structure of a pier.

So, in the last of the light the flock disappears into the reeds in a moment. As they arrive at their roost there's a cacophony of twittering as positions are taken and lost; senior birds take the prime perches, leaving the rest to squabble over colder, more vulnerable, positions.

The closing 'act' is sudden. Among the audience at the lighthouse the regulars agree that the show was a good one, then head off for a warming cup of tea.

Visit

Newport Wetlands is owned and managed by Natural Resources Wales, while the RSPB runs the popular visitor centre and café at Uskmouth (grid ref. ST 334 834; www.rspb.org.uk), which is the best location for starling-watching. There is also a hide at Goldcliff (grid ref. ST369 828), which has views over wader lagoons.

Also

Heavy rain raises river levels in November and that gives the salmon that have gathered in estuaries a fighting chance to head for their spawning grounds. Swimming against fast-flowing rivers, they have to leap weirs and waterfalls along the way. See them on the Afon Marteg at Gilfach Farm, Radnorshire (grid ref. SN 965 717, rwtwales.org); in the centre of Cardiff at Blackweir on the Taff (grid ref. ST 170 780) and at Cenarth Falls (grid ref. SN268 416), near Newcastle Emlyn, Carmarthenshire.

December

12. Flying high
Gigrin Farm, near Rhayader, Powys

Gigrin Farm kite-feeding centre is 0.6 miles (1km) to the south-east of the centre of Rhayader.

High over the busy market town of Rhayader, a single large bird is flying south. Although it's no more than a silhouette against an iron-grey sky, it's still unmistakeably a red kite.

Some distance back, and higher still, a second kite is on the move too – and on the same bearing. Both travel with a businesslike, flapping flight that's all about getting from A to B.

A few decades ago, the chances of spotting one kite anywhere in Britain were remote, let alone two. Now though, you will probably see kites soaring effortlessly on thermals along the way on most cross-country journeys in Wales. And the birds are now also widespread in much of England and Scotland, too.

However, to be guaranteed a kite-sighting it pays to go to one of the feeding stations that have played a part in the species' comeback in Wales. The birds flying over Rhayader were almost certainly on their way to the daily feed at one of those centres, the oldest, and arguably best, Gigrin Farm.

Kites have been fed meat scraps at Gigrin since the early 1990s. Birds are attracted to the farm's feeding station all year round, but visit in their hundreds during the winter months. The largest numbers turn up when the weather is especially testing.

Lots of other birds arrive for a share of the feast too, including carrion crows,

Right: A red kite turning in some beautiful golden light. If there were ever a bird to epitomise the Welsh countryside, this would be it.

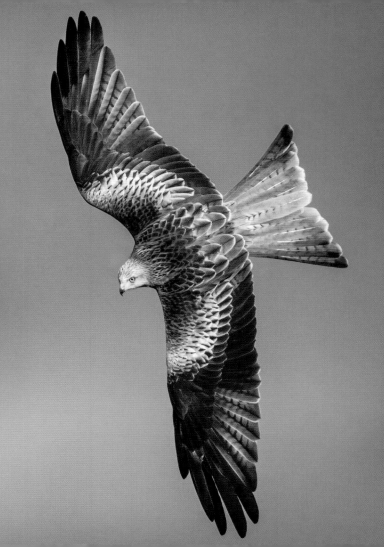

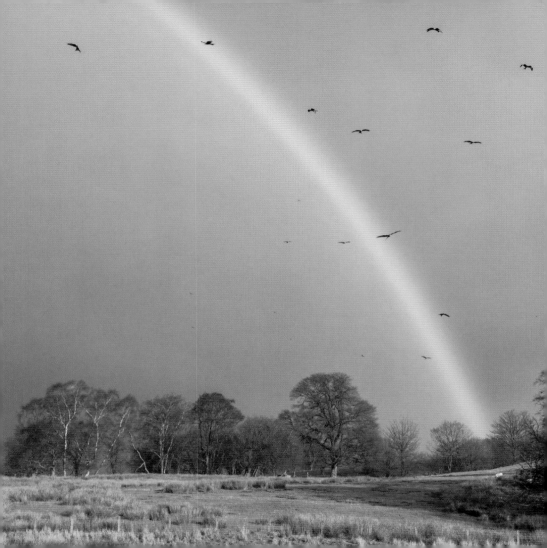

jackdaws, ravens and buzzards. It makes the afternoon feeding sessions noisy free-for-alls that involve conflict on the ground and in the air.

Birds turn up early. The crows wait in the branches of nearby trees, while scores of kites and buzzards circle overhead.

When the meat scraps are finally scattered, all hell breaks loose. But while the other birds fight for their share on the ground, the kites prefer to remain on the wing.

It offers the viewers in the farm's bird hides the chance to witness the red kite's aerial agility up close. They are incredibly agile, their large wings and forked tail allowing them to swoop and dive before finally skimming the ground to take a chosen scrap.

Seeing so many birds in the air is quite overwhelming, but there's possibly more order to it all than there seems. Exactly when individual kites get to take their share of the food seems to be dictated by a social 'pecking order', with older birds eating before youngsters get their turn.

Over the years, Gigrin Farm has become quite an attraction, as have the other kite feeding stations. Indeed, the red kite has become something of an emblem for mid-Wales; the area's local authority has a red kite logo and tourism marketeers like to promote 'Kite Country' as a destination.

The red kite has become something of an emblem for mid-Wales.

If there is a Kite Country, it's the Cambrian Mountains, the upland stronghold in which the birds survived when the species came within a feather's-breadth of British extinction during the 20th century. The term 'Cambrian Mountains' was once a catch-all term for all of upland Wales, but since the middle of the last century it has been used to describe a much more defined area.

It's an area that actually came close to being made a National Park in the late 1960s and early 1970s. That park would have stretched from Machynlleth in the north almost to Llandovery in the south.

Gigrin would have been close to the park's eastern boundary, while in the west it would have come close to Tregaron. It is an area that has the feel of being the heartland of Wales and comes close to being its watershed – it's the source of the Teifi, Tywi, Wye and Severn rivers, plus lots of smaller ones too.

Left: Up to 600 birds can gather during the winter months at Gigrin.

The mountains are very thinly populated. The English angler John Henry Cliffe wrote about his travels in the area in the late 1850s and found it "untamed and desolate".

He was unimpressed by the "vast sweeping ranges of hills with rounded tops" and missed human contact. "It has indeed with perfect truth been called 'the great desert of Wales'," he wrote.

That emptiness is probably what saved the Welsh kite. The species was once widespread; until around 300 years ago red kites bred throughout Britain.

They were even part of the urban scene. In Shakespeare's time they are thought to have been a common sight in London and other British cities; in Coriolanus the capital is referred to as "the city of kites and crows".

A scavenger like the kite, which cleaned up the streets, presumably served a useful purpose. However, over time attitudes to kites changed and they were declared vermin under the law.

Useful or not, it meant that kites were poisoned, trapped and shot. Persecution intensified when, at the end of the 18th century, increasing numbers of gamekeepers were employed on country estates.

Keepers killed many more birds and by the late 18th century red kites had been lost from much of England. The Victorian fashion for egg collection and taxidermy added to the kite's woes; by the late 19th century, breeding kites are thought to have become confined to what are now the counties of Carmarthenshire, Powys, Ceredigion.

As the birds became scarcer they came under ever growing pressure, because collectors wanted specimens to complete their collections. Large sums of money were paid for a dead kite or a kite's egg.

Finally, their plight prompted a conservation effort. As early as the 1880s a Brecknockshire solicitor, Alfred Gwynne Vaughan, and a clergyman, David Edmonds Owen, were offering a reward to farms that allowed kites to nest in peace.

Their efforts could do little to ease pressure on the species. By the early years of the 20th century a kite committee was set up by concerned ornithologists to protect the species wherever possible, but it too could only slow the rate of the species' decline.

In his 1976 book *British Birds of Prey*, Leslie Brown says of the red kite: "The onslaught of egg collectors and skin collectors may have reduced the remnant to as few as four or five surviving pairs."

Right: Red kites are now spreading across the whole of Wales, after coming close to extinction in the 20th century.

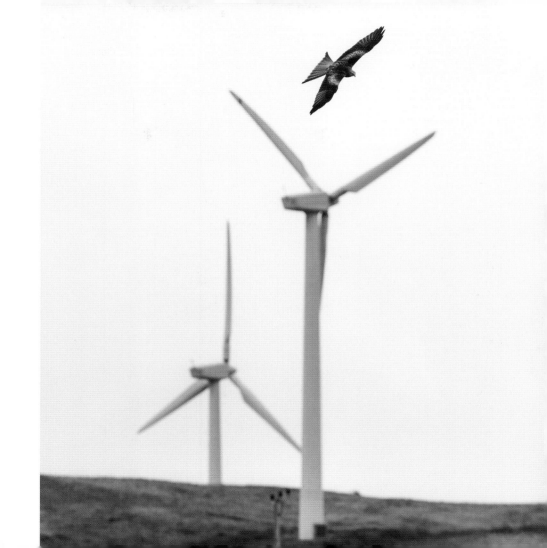

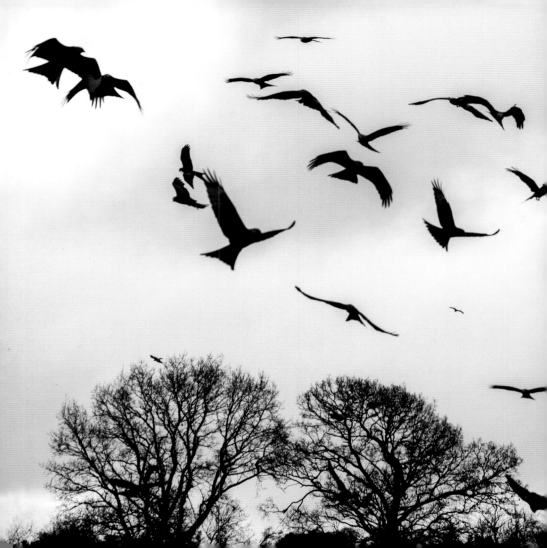

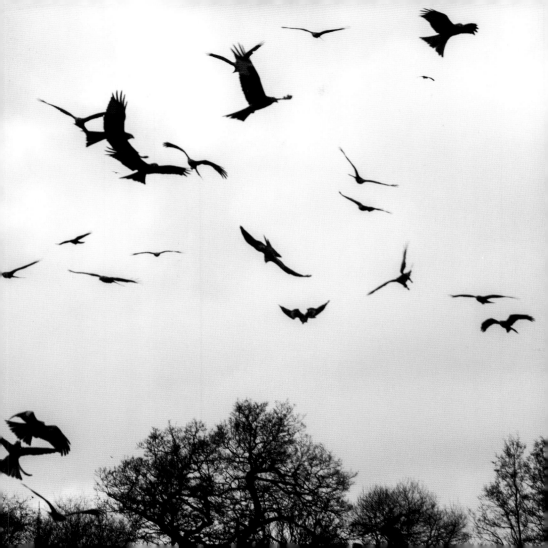

The last thirty years of the 20th century saw the Welsh kite population undergo a remarkable recovery as the public opinion shifted.

But a corner was being turned at around the time that Brown was writing his book. In some years in the late 1950s, Brown says, as few as seven kite pairs nested and just seven youngsters were reared successfully.

By 1972 that total had risen to 26 pairs, together raising a total of 19 youngsters. Brown spoke of a "shaky gradual climb" to a Welsh population of around 70 kites, including adults and youngsters.

The last thirty years of the 20th century saw the Welsh kite population undergo a remarkable recovery as the public opinion shifted. In *The Red Kites of Wales,*

Tony Cross and Peter Davis say: "Public attitudes towards the kite were gradually changing, bringing increasing sympathy for protection and conservation, and a growing attachment to the bird as a symbol of Welsh individuality."

Improved protection and campaigns against poisoning and egg theft gave kites the chance to thrive. By 1993 the population in Wales climbed to 100 breeding pairs for the first time in a century.

During the 1990s, as the Welsh kite population was recovering, kites were being re-introduced into parts of England and Scotland. Those re-introductions have proved successful and the British breeding population is now thought to be around 1,600 pairs – roughly a third nesting in Wales.

And as kites have become more common they have moved way beyond the old Kite Country heartland. In the days of human persecution the lonely Cambrian Mountain uplands may have offered sanctuary, but now kites are re-entering

Above: Kite Country. A red kite soars high over the wooded valley of the Rheidol.

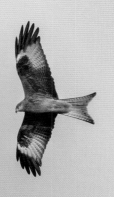

lowland areas, where the living is often easier.

In breeding season a nesting pair's hunting ground takes in around 10 square miles, but in winter kites range much more widely. In still air a kite's flight is almost laboured, but when there are thermals to ride it can stay in the air for hours with near to no effort.

A kite has a lightweight body and a comparatively large wingspan. An adult kite is about 63cm (25in) long, has a wingspan of about 185cm (73in) and a body weight of just 900 to 1300g (32oz to 46oz).

Set that against the vital statistics of a common buzzard. An adult buzzard weighs just a little less than a kite and has a shorter body length at about 54cm (21in) long, but its wingspan is just 120cm (47in).

From its high-level vantage point, a soaring kite can search for food. They nest and roost in woodland, but hunt where they can put their excellent eyesight to use inspecting open terrain.

They also hunt live prey, including small mammals and medium-sized birds like carrion crows and magpies.

They look for carrion – that is dead animals. In the sheep country that's often fallen stock, but they are also attracted to roadkill of all kinds.

They also hunt live prey, including small mammals and medium-sized birds like carrion crows and magpies. But a significant part of their diet is made up of much smaller prey like beetles and earthworms.

And it's possible that in lowland areas they can find more to eat because prey is more plentiful than it is in the uplands. It looks as though the kite is coming home.

Visit
Gigrin Farm (grid ref. SN 983 679; www.gigrin.co.uk) is open all year round, except for Christmas Day. Kite feeding happens at 2pm during the winter months and is at 3pm after the clocks change in March.

Also
Kite-feeding also happens at feeding Bwlch Nant yr Arian Visitor Centre (Grid ref. grid ref. SN 717 814; www.forestry.gov.uk) at Goginan, near Aberystwyth, Ceredigion, which is run by Natural Resources Wales, and at Llanddeusant Feeding Station (Grid ref. SN777245; www.redkiteswales.co.uk) near Llangadog, Carmarthenshire, in the Brecon Beacons National Park.

Behind the shots

Drew takes us through a selection of his most memorable moments from his time spent photographing for Wilder Wales.

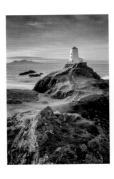 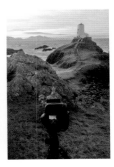

January: Tŵr Mawr, Llanddwyn Island
Sunrise on Llanddwyn Island, Anglesey with the morning sun hitting the lighthouse of Tŵr Mawr and the peaks of the Llŷn Peninsula in the distance. A long walk to get to this place for dawn, over a mile trudge along Newborough beach. Timing it with the tide proved tricky, with the last of the high tide remaining, which made for a bit of a water rock-hopping crossing between Newborough beach and nearby Malltraeth Bay.

It's a beautiful spot here at any time of day and a well photographed place at that. When shooting landscapes you always try to look for aspects that link up throughout the scene, boosting the depth and interest. The composition I've chosen here uses the natural curvature of the foreground rocks to lead the eye down and along to the opposite curve of the steps leading to the main focal point – the lighthouse. Early morning sun helps to give some lovely, golden side lighting, contrasting with the shadows. You could be fooled into thinking this isn't Wales, but it is, and what a fabulous part of our country.

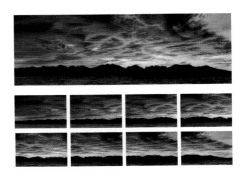

January: Snowdonia Sunrise

This was taken shortly before the lighthouse image on Llanddwyn Island. Arriving at the car park on Newborough beach in the dark around 7am, and wearing many layers on a cold January morning, I started the long walk down the beach to the island. Walking due west I started to see the glimmer of some colour in the sky and the mountains begin to appear. Still only half way to the island I had to pick up the pace and walked as quickly as I could along wet sand in wellies until I reached the tide crossing for the best viewpoint of the mountains. By this time the sky was on fire. I know light like this can only last minutes sometimes, so I set my camera up on a tripod with a longer lens. Shooting with a longer lens and taking lots of images to combine into a panoramic will make for a much fuller resolution final shot. Dialling in the same settings and shooting one by one from left to right, I took over sixty images in total. The final panoramic is made up of the best eight images with enough overlap to stitch them together to make this striking final composite shot of the Snowdonia mountain range.

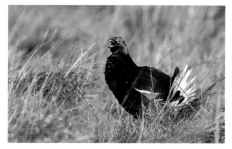

April: Black Grouse

Photographing these amazing birds has always been on my hit list and to photograph them in Wales – what an

honour. Previously I'd have thought I would need to go to the Scottish Highlands to get a glimpse, but they're here in Wales for all to enjoy. What made it even more special for me was having permission to set up a hide on the very moors that they call home and get close to the action. With thanks to help from my friend Mike Warburton, we headed up onto the moor once the birds had finished their lekking for the day. We set up our hide while standing knee-deep in boggy moorland in the fog and rain. Using the natural cover of a fallen tree, we placed the hide inside and built around it using some branches to make it unnoticeable in the landscape. Our hide was a good quarter mile from the road across featureless moorland, and on returning the next morning it was tricky to find again, even with a torch (I guess we did a great job of camouflaging it). We finally found it and set up the camera up at around 4am, ready for the birds to arrive at about 5am. From the silence of the darkness, we started to hear noises and make out white tail feathers moving around. I'd never seen or heard a black grouse before; the eerie sound of those guys bubbling and calling just feet away was definitely a unique experience and one that I'll always remember.

May: Bluebells

Other than the daffodil, there's nothing more significant in spring than the carpets of bluebells covering our native woodland. It's a British scene we should be proud of; half the world's bluebell woods are found in Britain, so it's no wonder we have a real affection for them. Photographing them can be tricky though, as most of the time what you see with your eyes is never related onto camera. A good technique is to drop to their level; this will increase the effect of density. Also use a circular polariser filter, as it will cut down any foliage reflections and boost colouring. Still, you need to use the correct settings and time it right together with peak flowering and time of day, but those two tips will definitely help your shots. Other possible shots would be

backlighting at sunrise or sunset, together with being creative with low shutter speeds to include motion blur; either induced by the wind or camera movement.

June: South Stack Lighthouse

We had a great weekend up on Anglesey for this chapter, but blue skies and warm temperatures aren't the best for landscape photography with harsh lighting and high contrast scenes. On the Sunday morning we were greeted with a bit of murky weather, so it was the perfect time to play around with the camera. My ten stop neutral density filter reduces light intake ten times, which allowed me then to use a longer shutter speed to create blur in the water. Coupled with a circular polariser filter to reduce surface reflections and boost colours, it made the water look tropical on what was an overcast day. Finally, a two stop soft graduated neutral density filter held back the area of the sky and sea to evenly expose the image. There's quite a height drop from the steps down to the island itself, so compressing the depth was key to making a feature-packed scene right down to the main focal point, the lighthouse. With a bit of jiggery thanks to my tripod I managed to get the camera where I wanted it for it to be still through the thirty second exposure.

August: Manx Shearwaters

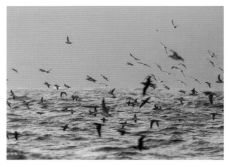

This proved to be one of the trickiest subjects to capture during our trips around Wales. The main focus of the chapter would be the fantastic Manx shearwater. However, the birds are either

visible at night on the remote island or it's a question of heading out in a boat to hopefully find some out to sea. Loving some adventure, we opted for a boat trip out. Embarking from Martin's Haven one evening, we headed out on a fast RIB which shot across over to Skomer and then on to Skokholm; it was really great fun bouncing over the waves with sea spray everywhere. Managing to cling on and not lose my kit overboard we saw a few birds flying around, so decided to follow them out to sea west of Skokholm. As the sun was nearing the horizon we stumbled on the mother lode: possibly over a thousand Manx shearwaters bobbing about on the sea. They spend most of the day effortlessly cruising over the waves and gathering in huge groups, called 'rafts', until they come into the islands at night under the cover of darkness. It was a fabulous spectacle photographing these from the boat as the sky turned orange, absolutely magical.

October: Wild Goats

Without a doubt, the hardest subject in this book; this was actually like finding a needle in a haystack, as I live over four hours from the region. It required two unsuccessful trips before finally tracking some goats down on the third. Even then it was a real slog, a full-on seven hours in the hills crossing boulder-strewn pathways and craggy ravines. Julian had seen them close by to this area going back six years or so, so after the first two failed attempts we thought, why not? After ascending high up into the Rhinogs and nearing the end of our walk we were pretty much giving up hope. Then we started to spot

of as a national emblem for a few decades (at that time), the symbolic standing of the leek was much older. The clincher was, she believed, a reference in one of Henry VII's domestic accounts to a payment for "bringing a leke to my lade grace on Saynt David Daye".

The next question is, which daffodil? The wild daffodils at Coed y Bwl are a British native, but are not uniquely Welsh.

There is a closely related species though – the Tenby daffodil – that is found in the wild only in Wales. In some places the two – wild and Tenby – grow side by side.

The two plants are fairly easy to tell apart. Where the wild daffodil has a yellow trumpet and paler petals, the Tenby daff is a uniform bright yellow.

Also, while both grow to about the same height, the Tenby daffodil stands straighter. It also tends to move less in the wind than a wild daffodil does.

The Tenby daffodil has a tiny home patch. As its name suggests, it can be found in and around Tenby and elsewhere in Pembrokeshire. It is also found in the neighbouring counties of Carmarthenshire and Ceredigion.

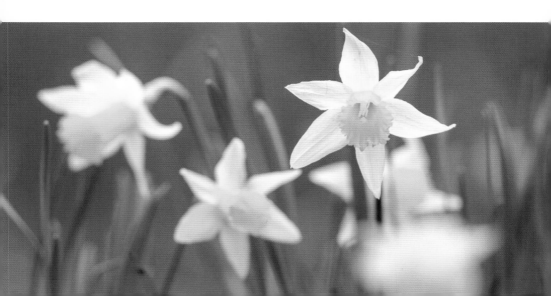

plenty of tracks, even some hair and fresh droppings. Surely they had to be close by. We pushed on some more, following the tracks over boggy ground and rock slabs until reaching a summit over-looking Llyn Morwynion, where we finally spotted three goats. Next step was to get the camera kit out and try to get nearer, using fieldcraft through natural cover and gullies to get within range without disturbing them. After a while they moved around to the other side, which meant pursuing them through the rocky landscape where every step could break your ankle. I managed to creep up on them once again and get some more images, then it was time to leave them in peace. We headed back down the mountain to have a well-earned brew in Julian's camper van. A very exhausting, but rewarding, day.

December: Soaring Spectrum
Images like this don't come together very often, so when they do it's very rewarding as a photographer. I was up at Gigrin Farm Red Kite centre in mid-Wales and we had the most amazing light. It was very changeable: from brilliant sunshine to torrential rain and back to sunshine again. During winter the kites are fed at 2pm and, if you're lucky, you can witness some lovely golden afternoon light. The kites were gathering and bang-on

feeding time there was sunshine and rain together, which produced one of the most vivid rainbows I have ever seen. I immediately set on trying to capture a kite flying through the colours. Shooting from the specially-built photography tower hide and using and choosing settings which would freeze any passing bird, I framed the best part of the rainbow. I tracked a few birds and hit the shutter the moment they soared through the colours, with the afternoon sun helping to illuminate the underside plumage. It wasn't until reviewing the image I realised I'd caught a buzzard as well in the same photo. A unique image in my eyes and a great addition to our book.

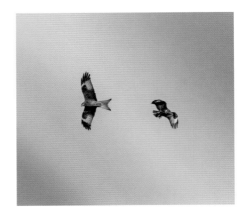

The next 12 wild locations

Wales has so many incredible wild locations that selecting the 12 that we visited during our year on the road proved a challenge. It meant some much-loved wild places didn't make 'the cut', so it seems to make sense to offer a second dozen for you to consider visiting when you have finished your own wild Welsh year. The grid reference refers to the Ordnance Survey Maps.

1. Bardsey Island

Grid ref: SH 117 213

Bardsey lies two miles off the coast of the Llŷn. It's an important stop-over for migrating birds in spring and autumn; its Bird Observatory has been monitoring the movements of migrant species since the early 1950s. Bardsey also has a Manx shearwater breeding colony and Risso's dolphins and harbour porpoises can often be seen around the island.
www.bardsey.org

2. Cors Caron

Grid ref: SN 690 642

One of Wales' most wildlife-rich wetlands, Cors Caron is a vast peat bog that has been 12,000 years in the making. Visit in summer to see dragonflies and curlew, while in winter it is a great place to spot birds like teal, wigeon and whooper swans.
www.naturalresourceswales.gov.uk

3. Craig Cerrig Gleisiad a Fan Frynych

Grid ref: SN 956 227

The reserve is a spectacular landscape that illustrates the transformative power of ice 20,000 years ago. An Ice Age glacier sculpted the reserve's cliffs and escarpments and its retreat left a debris of shattered rock. It remains a harsh environment and is the southern limit in Britain of arctic-alpine plants like the mossy saxifrage.
www.naturalresourceswales.gov.uk

4. Cwm Idwal

Grid ref: SH 642 590

Wales' first National Nature Reserve, Cwm Idwal is the perfect glacial cwm – a bowl-shaped hanging valley formed by glacier. Charles Darwin made several visits to the area to study its rocks and its plants, which include high-altitude species like tufted saxifrage, purple saxifrage and the Snowdon lily.
www.naturalresourceswales.gov.uk

5. Cwm Rheidol

Grid ref: SN 741 770

The steep-sided gorge of the fast-flowing River Rheidol is a magical place, especially in late spring when bluebells are in bloom. Pied flycatchers and redstarts breed in the valley's oakwoods in summer, while the woodland is also home to one of Wales' rarest mammals, the pine marten. www.naturalresourceswales.gov.uk

6. Elan Valley

Grid ref: SN 928 646

The Elan Estate is massive – altogether it extends to 70 square miles of moor, bog, woods, rivers and reservoir. A total of 180 different species of bird have been recorded on the estate since records began in the 1880s and some of Britain's rarest breed there, including merlin, hawfinch, golden plover and lesser spotted woodpecker.
www.elanvalley.org.uk

7. Grassholm

Grid ref: SM 597 092

Rocky Grassholm is 8 miles (13km) to the west of Pembrokeshire. Each year, many thousands of Atlantic gannets take up residence during the summer, packing the small island; it's thought that around 10 percent of the world's population breed there. www.rspb.org.uk

8. Great Orme

Grid ref: SH 756 839

The barren landscape of the landmark limestone headland comes alive in spring and early summer. During this time, the Great Orme's grassland, heath and limestone pavement are awash with wildflowers and butterflies are on the wing, including the rare silver-studded blue. Look out to for the headland's herd of wild goats.

9. Kenfig

Grid ref: SS 793 817

The expanse of sand dunes at Kenfig are a great place to see wild orchids when they are in bloom in early summer. Of the 10 species that grow on the reserve the rarest is the fen orchid, which grows only in south Wales and East Anglia. About half of the UK fen orchid population is at Kenfig. It is also a good location for bird-watching, especially in winter, when wildfowl gather on Kenfig Pool.
www.naturalresourceswales.gov.uk

10. Skomer

Grid ref: SM 723 094

The most popular of the Pembrokeshire islands, Skomer is a must-do wildlife-watching location. It is at its best in June and early July, when many thousands of seabirds nest on the island, including puffins, guillemots, razorbills and Manx

shearwaters. Though the seabirds are the stars of the show, there is much more to see – everything from the grey seals that sunbathe on inter-tidal rocks to the glow-worms that light up summer nights.
www.welshwildlife.org

11. Snowdon
Grid ref: SH 629 526
At 1,085m (3,560ft), Snowdon is the highest mountain in Wales. Its summit is also at the heart of a large nature reserve that extends to nearly 1,700ha (4,160 acres) of mountain, moor and woodland. Many rare plants thrive in the harsh environment, most notably the Snowdon lily. It is also the place to see birds like peregrine falcon and merlin.
www.naturalresourceswales.gov.uk

12. Waterfall Country
Grid ref: SN 928 099
In a small area of the Brecon Beacons National Park the proximity of old red sandstone and a belt of limestone has created an incredible landscape of gorges, fast-flowing rivers and waterfalls. In the oak and ash woods the humid atmosphere provides the perfect environment for mosses, liverworts and ferns, which carpet every surface. Look out for dippers and grey wagtails and, as darkness falls, bats hunting over the water.
www.breconbeacons.org

Conserving wild Wales

Natural Resources Wales
Lots of different organisations are involved in caring for the natural environment of Wales and its wild animals and plants. Since 2013, the official body responsible for the environment and conservation has been Natural Resources Wales (NRW), which took over the work of Countryside Council for Wales, Environment Agency Wales and Forestry Commission Wales. One of NRW's jobs is to care for Wales' 72 National Nature Reserves (NNRs). The NNRs are the nation's most valued wildlife locations – we have featured many of them in this book.
Find out more at about NRW at www.naturalresourceswales.gov.uk

National Parks
About a fifth of Wales is protected, either as a National Park or an Area of Outstanding Natural Beauty (AONB). Both the National Parks and AONBs play a role in the protection of landscapes and nature.
• Brecon Beacons National Park: www.beacons-npa.gov.uk
• Pembrokeshire Coast National Park: www.pembrokeshirecoast.org.uk

- Snowdonia National Park: www.eryri-npa.gov.uk

Areas of Outstanding Natural Beauty

Wales has four Areas of Outstanding Natural Beauty and shares a fifth, Wye Valley, with England.
The five are:
Anglesey: www.anglesey.gov.uk
The Clwydian Range and Dee Valley: www.clwydianrangeanddeevalleyaonb.org.uk
Gower: www.swansea.gov.uk
Llŷn: www.ahne-llyn-aonb.org
Wye Valley: www.wyevalleyaonb.org.uk

Get involved

Lots of the conservation work that happens in Wales is carried out by charities, often with the help of volunteers. The organisations involved include country-wide membership bodies, like the National Trust, the Royal Society for Protection of Birds (RSPB) and Coed Cadw (the Woodland Trust), and smaller charities that focus on a geographical area, like the North Wales Wildlife Trust, or one part of the natural world, like Plantlife.
Here are a few of the main 'players':

- Butterfly Conservation www. butterfly-conservation.org
- Coed Cadw www.coed-cadw.org.uk
- National Trust www.nationaltrust.org.uk
- Plantlife Wales www.plantlife.org.uk
- RSPB www.rspb.org.uk
- Wildfowl & Wetlands Trust www.wwt.org.uk
- Wildlife Trusts www.wtwales.org

Acknowledgments

Lots of people throughout Wales were generous with their time and expertise while this book was in the making. So, many thanks to Helen Buckingham, Nigel Brown, Kevin Dupe, Steve Hartley, Lyndsey Maiden, Greg and Lisa Morgan, Ben Sampson, Craig Shuttleworth, Dana Thomas, Colin Wells and Lizzie Wilberforce.

Thanks are due also to Peter Gill and Matthew Howard at Graffeg. Firstly, for seeing merit in the idea, and then having the patience to let it happen.

Finally, credit should go to Sidney, Andrea and Drew's dog, who joined us on some of the trips. An invaluable member of any team!

Seasonal timeline

January:
- Raven numbers peak at roost
- Estuary wader flocks
- Starling mega flocks
- Red kite numbers peak at feeding stations

February:
- Estuary wader flocks
- Frogs mate at breeding ponds
- Brown hares 'boxing'
- Wild orchids in bloom

March:
- Dawn chorus
- Dolphin-spotting
- Frogs breeding
- Brown hares 'boxing'
- Wild daffodils in bloom
- Black grouse lek

April:
- Brown hares 'boxing'
- Dawn chorus
- Badger cubs leave sett

- Black grouse lek
- Bluebells in bloom
- Seabird colonies
- Dolphin-spotting

May:
- Dawn chorus
- Badger cubs leave sett
- Black grouse lek
- Bluebells in bloom
- Wild orchids in bloom
- Seabird colonies
- Dolphin-spotting

June:
- Wild orchids in bloom
- Seabird colonies
- Dolphin-spotting

July:
- Wild orchids in bloom
- Seabird colonies
- Dolphin-spotting

August:
- Dolphin-spotting
- Seal pups born

September:
- Dolphin-spotting
- Seal pups born
- Feral goat rut
- Deer rut

October:
- Estuary wader flocks
- Seal pups born
- Feral goat rut
- Deer rut

November:
- Estuary wader flocks
- Seal pups born
- Starling mega flocks
- Red kite numbers peak at feeding stations

December:
- Raven numbers peak at roost
- Estuary wader flocks
- Seal pups born
- Starling mega flocks
- Red kite numbers peak at feeding stations

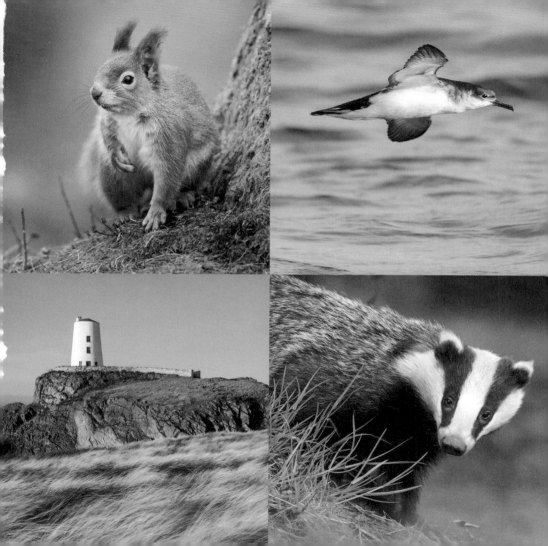